The Campus History Series

EMPORIA STATE
UNIVERSITY

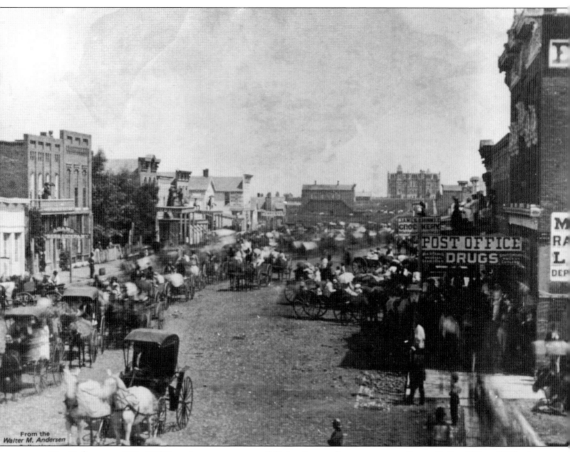

From the
Walter M. Andersen

On February 20, 1857, a town was established on the eastern edge of the Flint Hills in what was then Breckenridge County, Kansas. The town was named Emporia after the great Carthaginian financial center in fond hope that it would one day rival the ancient city. In 1863, the Kansas Legislature passed a bill establishing a normal school in Emporia. Land was appropriated by the city for the construction of the school on the north end of Twelfth Avenue and Commercial Street. This 1870s image shows the normal school's main building—standing like an educational fortress on the Kansas prairie. (Courtesy of Walter M. Andersen Collection, Emporia State University Libraries and Archives.)

ON THE COVER: The Sunken Garden has been a favorite spot on the Emporia State University campus for students and alumni since 1917. The refreshing fountain and colorful flowers create a relaxing area to become acquainted with new friends or share memories with old ones. The garden was created following the removal of the old main building when the new administration building, Plumb Hall, was completed in 1917. (Courtesy of Emporia State University Libraries and Archives.)

The Campus History Series

EMPORIA STATE UNIVERSITY

STEVEN HANSCHU
FOREWORD BY MICHAEL D. SHONROCK, PhD

ARCADIA
PUBLISHING

Copyright © 2013 by Emporia State University
ISBN 978-0-7385-9874-1

Published by Arcadia Publishing
Charleston, South Carolina

Printed in the United States of America

Library of Congress Catalog Card Number: 2012949796

For all general information, please contact Arcadia Publishing:
Telephone 843-853-2070
Fax 843-853-0044
E-mail sales@arcadiapublishing.com
For customer service and orders:
Toll-Free 1-888-313-2665

Visit us on the Internet at www.arcadiapublishing.com

To all the students, faculty, staff, alumni, and the community who make Emporia State University an outstanding institution.

CONTENTS

FOREWORD

I was very fortunate to arrive on the campus of Emporia State University at a very exciting time. One of my first tasks was to move deliberations about a sesquicentennial celebration from speculation to realization. This made it a terrific time for me to learn significantly more about Emporia State University and its history and people while we remind some and introduce others to ESU's legacy. Because a picture is worth a thousand words, it would take several books of text to get across this information. How lucky are we to get to save so much time!

Steven Hanschu, reference and local history librarian in the William Allen White Library, has done a spectacular job in pulling together these images from a variety of sources. More than 30 years of experience at Emporia State University and significant involvement in community programs and organizations makes him a consummate choice for this assignment. He has astutely brought others into the project to ensure a range of perspectives.

Most of all, I appreciate this panorama of people, places, and events that have gone into transforming the lives of those who encounter Emporia State. "Changing Lives Since 1863" is the appropriate phrase adopted for our 150th anniversary.

For many readers, they will find in these pages pleasant reminders of how their lives were changed by the faculty who taught them, the enduring friendships they made, and the lifelong curiosity that was engendered during their days in Emporia. For others, they will learn more about a fabled teachers college, which garnered countless accolades while quietly expanding its services and degrees. And for some, it will be a great surprise to run into one of higher education's best-kept secrets.

Steve has adroitly arranged materials to show the story of how Emporia responded to the state's educational needs. When Kansas needed teachers for one-room schoolhouses, which dotted the plains and the Flint Hills, Emporia became its first normal school. When Kansas changed standards for teacher preparation, Emporia became a state teachers college.

And as Kansas saw its educational level rising and needed to offer its citizens graduate degrees, Emporia became a state university.

For 150 years, Emporia State University has been changing lives through educational opportunities.

My hope is that this book will enhance how you think of Emporia and its community. Let me know what you think.

—Michael D. Shonrock, PhD
president of Emporia State University

ACKNOWLEDGMENTS

As a three-time alum of Emporia State University, an employee of the university for over 30 years, and a researcher of Emporia history, I thought I was fairly knowledgeable about the history of Emporia State. To my joy and delight in the research for this book, I discovered many new amazing facts and stories about this great educational institution. Retracing the steps of ESU's history, from a borrowed classroom to the vibrant campus of today, has given me a greater appreciation of the important role this university has had to the state of Kansas and across the nation.

Unless noted otherwise, all images appear courtesy of Emporia State University Libraries and Archives.

I wish to thank the library and archival staff of William Allen White Library for their assistance in preparing for this book. Special thanks go to John Sheridan, dean of Emporia State University Libraries and Archives, for his support, release time, and encouragement to meet deadlines.

Thanks also go to Tyler Curtis, ESU alumni director, and the 150th Anniversary Steering Committee for their confidence and support to ensure that this publication will celebrate the history of ESU. My appreciation goes to the editors of Arcadia Publishing and Diana Kuhlmann, associate vice president for fiscal affairs, for working through all the contractual arrangements.

Special thanks go to library student worker Bethanie O'Dell for scanning the majority of the images found in this book. Finally, a thank-you goes to my wife, Beth, for her constant support.

INTRODUCTION

On the morning of February 15, 1865, Lyman B. Kellogg, principal of the state normal school in Emporia, Kansas, walked up the stairs to a large room of the stone schoolhouse belonging to School District No. 1 of Lyon County. Greeting him was a small band of 18 students. Long settees were borrowed from the Congregational church for the use of the students. A *Webster's Unabridged Dictionary* and a small Bible, the property of the teacher, were on the table and constituted the library. From these humble beginnings, the first Kansas State Normal School has grown to one of the renowned teacher education institutions in the nation, changing the lives of thousands of students since its founding.

The establishment of three institutions of higher education in the state of Kansas happened during the state legislative session of 1863, only two years after Kansas achieved statehood. Even during territorial days, Kansas political leaders were discussing a state university with possible locations in Manhattan, Lawrence, and Emporia. During the session of 1863, the Kansas Legislature passed a bill that the Kansas State Agricultural College be located in Manhattan. At the same time, Lawrence and Emporia were vying for the state public university. Lawrence won the site by one vote. Not to be left out, Rep. C.V. Eskridge from Emporia introduced a bill to establish a state normal school at Emporia. The bill passed both houses and was signed by Gov. Thomas Carney on March 3, 1863.

In 1867, a two-story stone building was erected on the site selected at the head of Commercial Street for the Kansas State Normal School. With growing enrollment, a larger structure was erected to the south in 1872. Destroyed by fire in 1878, this structure was rebuilt and enlarged. At the beginning of the 20th century, additional structures were built on the campus surrounding the original building. From an enrollment of eighteen, the normal school was evolving into one of the best teacher training institutions in the nation.

Since the first classes held in 1865, the university has prided itself on providing the best possible education for its students. In the eighth biennial report of the board of regents for 1891–1892, Kansas State Normal School was reported as the largest normal school in this country, if not in the world. As the school continued to develop, grow, and change its curriculum to meet the needs of the students, its name was changed to Kansas State Teachers College in 1923, to Emporia Kansas State College in 1974, and to Emporia State University in 1977. Over the years, ESU has also been recognized for its leadership in multicultural diversity, handicapped accessibility, faculty-student ratio, summer theater, state music festivals, and a host of other programs.

What always remains, though, from the years spent at an academic institution are the traditions, memories, and friendships. Thomas W. Butcher, president from 1913 to 1943, wrote the following in the 1924 *Sunflower*:

> The imperishable records of an institution of learning are written in its traditions. These are never officially kept. And so it comes about that the students themselves keep a record of persons, organizations and events, a kind of spiritual record, for the years—years which lie yonder in the distance when official records will be forgotten and spiritual records alone will endure.

Browsing through these pages filled with images, ranging from a small one-teacher school to a thriving academic university, it is hoped that a sense of spiritual record will evolve to see how the lives of many have been changed since 1863 at Emporia State University.

One

FROM HUMBLE
BEGINNINGS

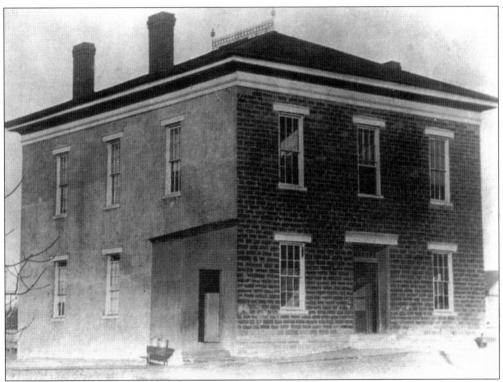

On the wintry day of February 15, 1865, Prof. Lyman B. Kellogg conducted the first class session of the Kansas State Normal School on the second floor of this stone schoolhouse, which belonged to Lyon County School District No. 1. The room was unfurnished. Settees for the students were borrowed from the Congregational church. A small table was borrowed from a notary's office, and a yellow-painted armchair for the teacher came from the county treasurer's office. For two years, classes were held here while a new building was being erected on the land platted for the institution.

Lyman B. Kellogg from Illinois State Normal School was selected as the first principal and teacher of the Kansas State Normal School. Kellogg, armed with a Bible and a dictionary, opened the first day by reading to 18 students the parable of the sower from the Bible and reciting the Lord's Prayer with the students. By the close of the school year, there was an enrollment of 43 students. Kellogg left Kansas State Normal School in 1871. He became a successful Emporia attorney and went on to become a member of the state legislature, a probate judge, and attorney general of Kansas. Kellogg Circle is named in his honor.

In 1866, the governor approved the appropriation of $10,000 for the erection of a building for the normal school. A 40-by-60-foot building with two stories on top of a basement was constructed on the 20-acre site selected at the head of Commercial Street. The upper story was used as an assembly room. The second story was divided in four rooms and could seat 120 students. One room was to be used as a model school. The basement contained dressing rooms and storage. If the building were standing today, it would be located southeast of the Sunken Garden. (Courtesy of University Photography.)

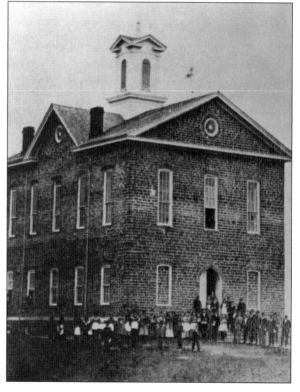

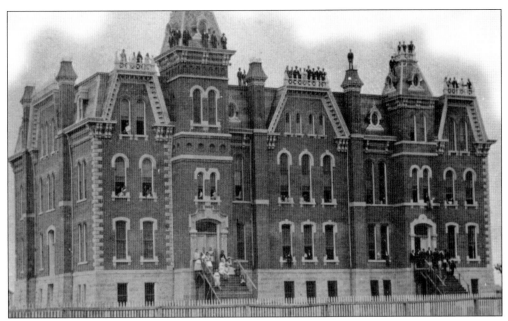

By 1871, enrollment had increased to more than 200, and more space was desperately needed. The state legislature approved $50,000 in 1872 to erect another building on the condition that the City of Emporia contribute an additional $10,000. The citizens promptly met the condition. The new Victorian Gothic brick structure was dedicated on June 19, 1873, where the Sunken Garden is now located.

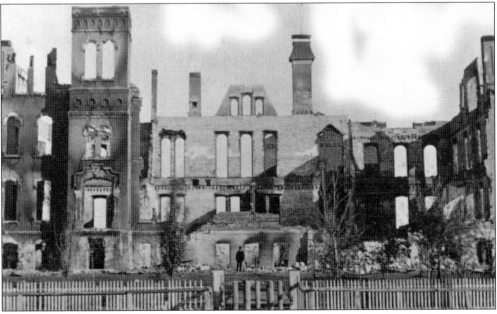

Disaster struck the normal school when fired broke out on October 26, 1878, destroying the five-year-old structure and the original stone building located behind it. The cause of the fire was blamed on spontaneous combustion of coal in the basement. The fire was so intense that flames could be seen for 16 miles and cinders flew across the Cottonwood River two miles away.

11

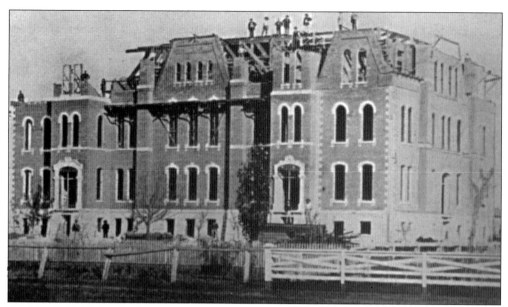

On March 7, 1879, a bill was introduced in the Kansas legislature to appropriate $85,000 for a new building with the provision that Emporia or Lyon County contribute $20,000. Realizing this was their only chance to save the school at Emporia, the citizens issued city and county bonds to meet the $20,000 provision. Faculty also served two years without pay in order to insure the continuance of the school. Construction on the new building started in spring of 1879 following the blueprint of the destroyed building. The 25-room structure could accommodate 400 to 600 students.

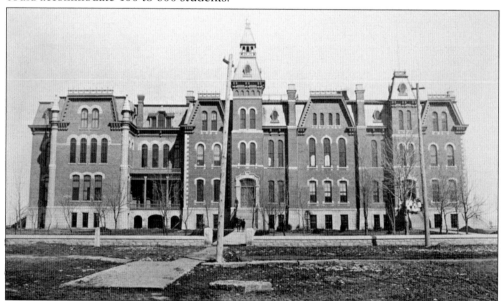

As enrollment continued to increase, additional space was once again needed. In February 1888, a 72-by-75-foot wing was added to the west end of the building. In 1894, another wing was added to the east for an assembly hall. Kansas State Normal School was now an imposing presence at the north end of Commercial Street in this thriving community, which was being called the "Athens of Kansas. " (Courtesy of University Photography.)

Albert R. Taylor served as president of the normal school from 1882 to 1901. Having been in classes Kellogg conducted at the Illinois Normal University, he was a protégé of Lyman B. Kellogg. During Taylor's tenure as president, Kansas State Normal School saw great growth. Some programs he instituted included 10-week sessions, summer school, commercial courses, and military drills. By the turn of the century, the school was thriving and enrollment and faculty had increased significantly. Albert Taylor Hall is named in his honor.

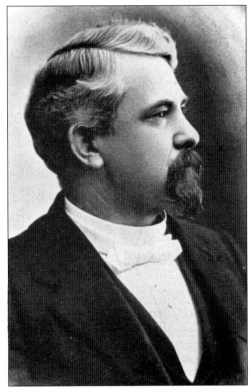

The new assembly room for the normal school was dedicated on September 4, 1894. The hall was one of great beauty with its proscenium arch and could seat 2,000 people. Of great interest to the public were the two dozen electrical lights along with the gas jets. To the surprise of President Taylor, the hall was christened the Albert Taylor Hall in honor of his service to the school. This 1906 image shows the hall decked out with American flags for a patriotic event.

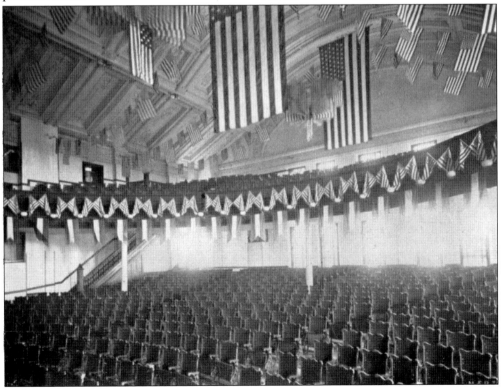

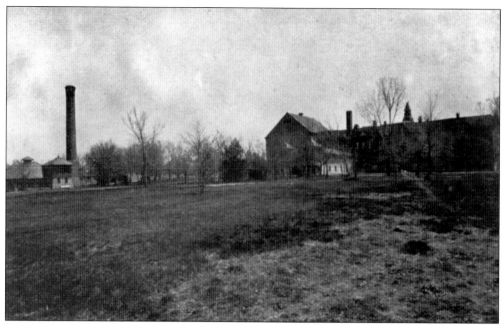

This 1901 image shows the rear view of Kansas State Normal School looking to the southeast. At that time, the only structures on the campus were the main building and the power plant, which had been built after the 1878 fire.

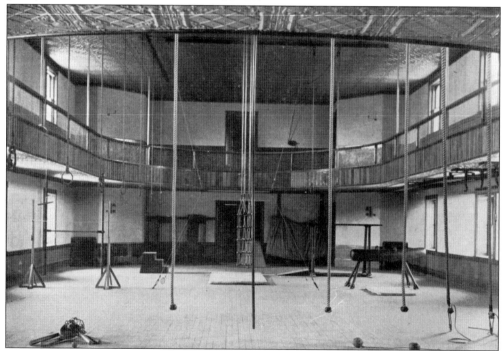

The main building housed not only classrooms, a model training room, library, music department, and offices but also a gymnasium. A balcony surrounded the gym where students and visitors could observe the athletic events being played. This image was taken in 1901.

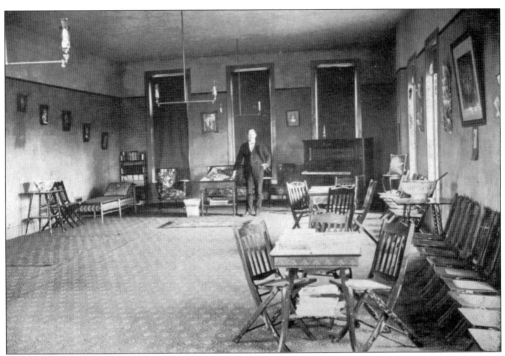

This interior room was one of the
most popular in the school. It was in
this upper room that Prof. Thomas M.
Iden held a Bible class, which became
a campus organization called the
Upper-Room Bible Class in 1897. The
group of 30 men in attendance at the
first meeting grew to several hundred
over the years. Unable to hold such
a large crowd, the organization later
met in the upper stories of several
downtown business buildings.

Thomas M. Iden was a professor of
physics at the normal school from
1897 until 1913. He is remembered
for organizing the Upper-Room Bible
Class for men. Meetings in the Upper-
Room Bible Class began with group
singing, followed by the reading
of letters from members traveling
all over the world. After music and
prayer, Iden would discuss that week's
Bible study, which he prepared. The
meeting concluded with the singing
of "Blest Be the Tie That Binds" and
Iden bestowing a fatherly good-night
to each boy and calling him by his
first name.

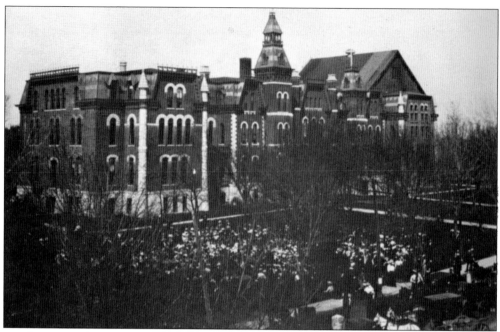

By the turn of the century, it became obvious that the main building was becoming inadequate to accommodate all the resources for the growing school. The library, containing 15,000 volumes, was being housed in four small rooms. In 1901, money was appropriated for a library building. This image shows the students and citizens of Emporia attending the ground-breaking ceremony for the structure.

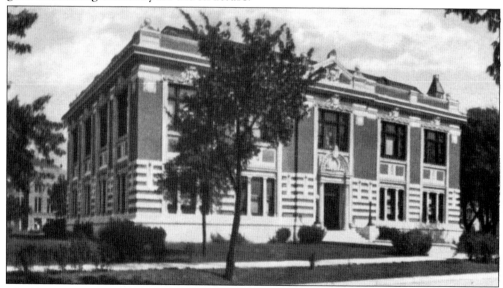

The library building was completed at a cost of $60,000 and was dedicated on November 5, 1903. The two-story structure was built of brick and terra-cotta. The first floor contained a large entrance hall and lecture room, which could seat 200. The main feature of the second floor was the spacious reading room that could accommodate 200 students. The library was named Kellogg in honor of the normal school's first president, Lyman B. Kellogg, and was located west of the main building.

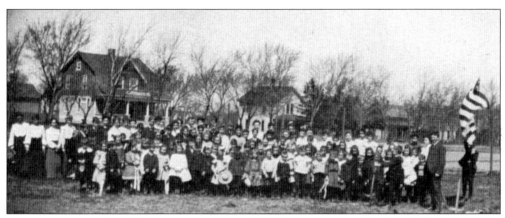

In 1903, a ground-breaking ceremony was held for a training school to help the normal students become good teachers. Students from the community and throughout the state could attend the training school to get an education. The ceremony was attended by many of the students then enrolled in the training school.

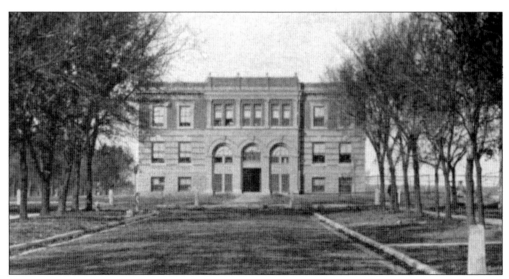

The new training school was ready for occupancy in 1904. It was located west of the main building, near the library. The name Training School and the dates 1864 and 1904 appeared above the main entrance as a reminder that it had been 40 years since the normal school was founded. There were three floors in the building. The first floor contained a gym, manual training room, lavatories, and heating rooms. The second and third floors contained recitation rooms, halls, cloakrooms, and closets for the different grade levels.

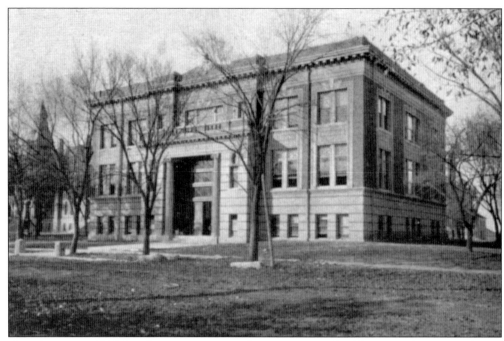

Plans began in 1905 for the construction of a new science building. Land was purchased from the Peters family just east of the normal school along Twelfth Avenue. The Peters house was moved to the rear of the lot and was used as a hospital. A ground-breaking celebration was held on November 17, 1905, when the 2nd Regiment band "drummed a crowd" from the downtown district to the campus. The building, dedicated in 1907, was named Norton Science Hall in honor of science professor Henry B. Norton, the second teacher at the normal school.

On April 15, 1910, a new Physical Training Building was dedicated. The structure was shaped like the letter *I*. The first story was divided into two exercise rooms with a rolling partition placed between them. The second floor contained men's and women's exercise rooms, classrooms, and offices. Two galleries were built at the top, with one containing a running track and the other supplying the seats for games. The building was in use until 1974, when the new HPER (Health, Physical Education, and Recreation) Building was completed. It stood where the parking lot is located north of the present library.

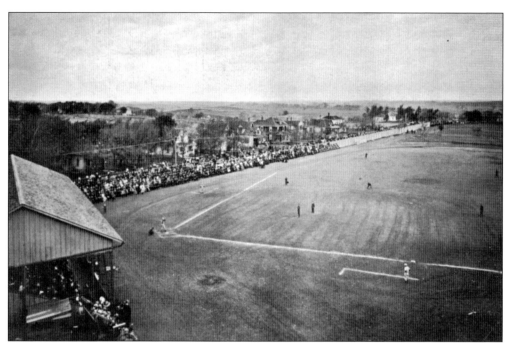

The athletic or playing field was an early feature of the campus scene. The field was used for all outdoor sports including football, baseball, soccer, field hockey, and track-and-field events. With the completion of the new gymnasium in 1911, the athletic field was a convenient location to the north along Merchant Street where the Science Hall and Cremer Hall now stands. This image shows the playing field in 1920.

By 1920, the Kansas State Normal School campus was beginning to take shape. The main building was in the center of the original 20-acre site. To the west of the main building were the library and training school. The Physical Education Building was behind the library. The science building was to the east the main building. This image was taken on the corner of Twelfth Avenue and Merchant Street looking northeast around 1910.

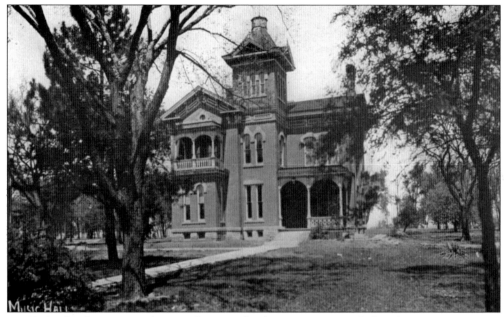

In 1910, the former residence of C.V. Eskridge was acquired for the growing music department. The brick Victorian home was remodeled, with a reception room in the center of the building and offices and classrooms located on the first and second floors. The home originally adjoined the east end of the campus.

Charles V. Eskridge was one of Emporia's earliest settlers, arriving in the spring of 1857, and served as the agent of the Town Company. Eskridge soon became one of Emporia's leading citizens. He was appointed a probate judge, served as a state legislator for many years, and was elected lieutenant governor in 1868. It was during these early legislative years that he helped establish the state normal school in Emporia. Eskridge had extensive holdings in land, railroads, and the First National Bank that provided him the means to build his large residence on East Twelfth Avenue.

The Belles Lettres Society was formed in 1888. The name Belle Lettres comes from the French language, meaning "beautiful letters." Both men and women participated in debates and wrote essays, poetry, fiction, and other literature. The debates and writing were often fierce, especially with the Illinois State Normal School. Prizes included medals, lithographs, paintings, and trophies.

The Philomathian Society was another popular literary society formed in 1892 because of the influx of students enrolling in the school. The Philomathian Society gained a prominent reputation by defeating the Belle Lettres Society in a debate during its first year of existence. The Philos yell was the following: "Whoo, gaw, haw, Whoo, gaw, haw, Philo, Philo, Rah, rah, rah!"

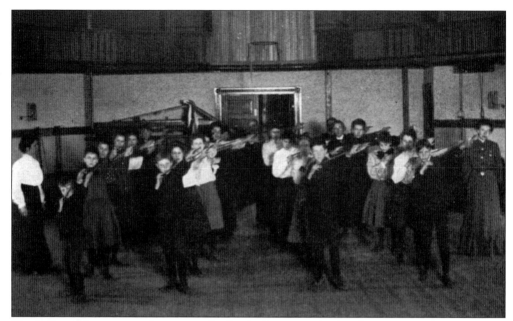

Physical well-being was important for both the normal-school students and the model-school students. In addition to older forms of calisthenic exercises, a Delsarte drill and voluntary military battalion were organized. Students also received special instruction in theory and practice. The seventh biennial report states that Eastern schools acknowledged the physical superiority of the Kansas State Normal School students.

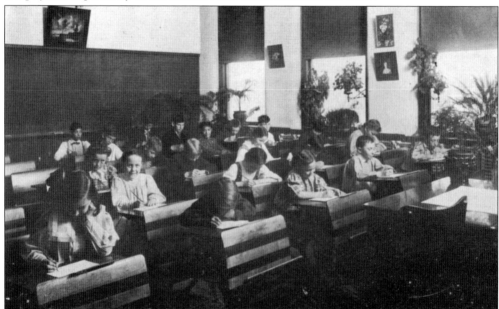

In 1865, Principal Kellogg announced the opening of an experimental school, or model school, in which "theory might be put into practice." Enrollment was limited to 30 students, with tuition set at $6 a term. Following the departure of President Kellogg in 1871, the model school was suspended but was reopened in 1873. Many children from the community attended the model school, which provided an opportunity for teacher training.

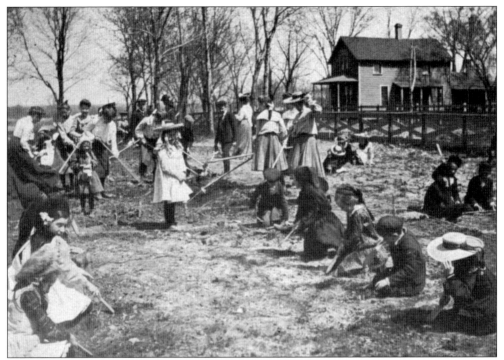

An important part of training for the children was tending the vegetable and flower gardens. The gardens gave an opportunity for children to learn about agriculture and how to care for the land. It also provided food for the families of many of the children and those in the community. This image shows the children tending the gardens, which were located behind the main building.

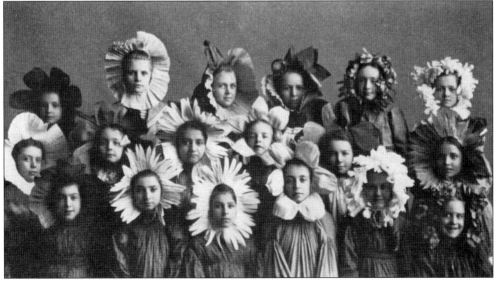

Not only did the model-school students acquire skills, but they also learned to appreciate music, art, drama, and reading. This image shows the children dressed in costumes for a play called *In the Garden*. These productions were held at all grade levels. The plays not only educated but also entertained families and the community.

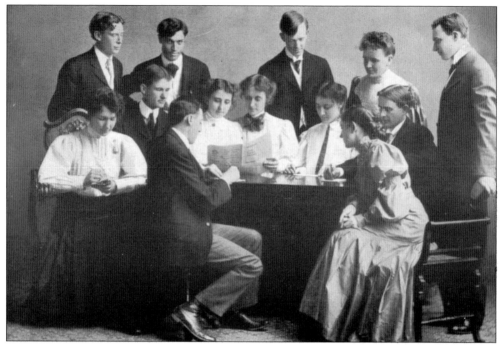

It was not long before students at the normal school were writing and printing a school newspaper call the *Bulletin*. These young students, as those of today, were dedicated to bringing current news and events to the other students, faculty, staff, and community. This image shows the *Bulletin* staff posed for writing in 1906.

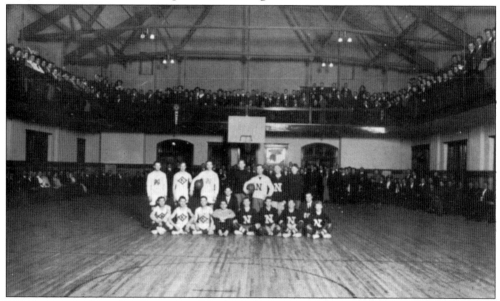

It did not take long for the sport of basketball to travel from the legendary courts of the University of Kansas to the Kansas State Normal School in Emporia. Basketball was popular with both men and women. This image shows the men's team of the Kansas State Normal School and the Warrensburg, Missouri, team posing for a group photograph in 1910. Missouri won the game by one point.

By 1899, the school had established itself as a leader in teacher education. Departments and courses were added on a regular basis to help students obtain degrees in four years. A zoology museum was started. Two additions had been made to the main building, and plans were underway for new buildings. Two graduated in the class of 1867; the class of 1899's 71 graduates included the first two of African American descent to receive diplomas.

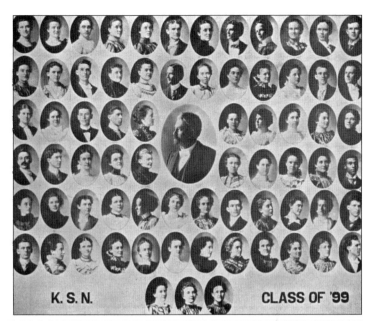

K. S. N. CLASS OF '99

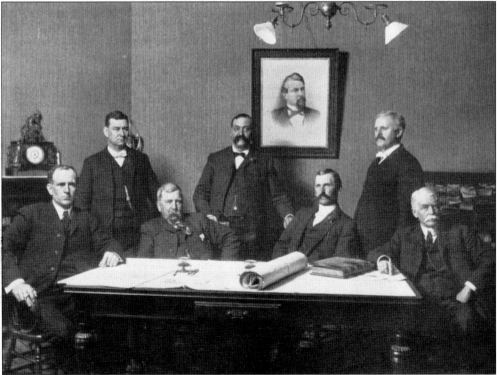

At the beginning of the 20th century, the Kansas State Normal School was one of five public universities in the state. Besides the University of Kansas and the Kansas State Agricultural School, two branches of the Kansas State Normal School had been established at Hays and Pittsburg, Kansas. At that time, Lyman B. Kellogg was serving on the board of regents. With his presence on the board, the normal school was well represented. Kellogg is the regent seated on the far right in this image.

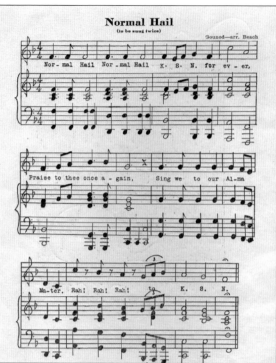

Normal Hail
(to be sung twice)

Gounod—arr. Beach

Nor-mal Hail Nor-mal Hail K. S. N. for ev-er,

Praise to thee once a-gain, Sing we to our Al-ma

Ma-ter. Rah! Rah! Rah! K. S. N.

The second known school song of the Kansas State Normal School was written by Frank Beach, professor of music at the normal school from 1909 to 1935. The song was written sometime before 1922. Preceding "Normal Hail," the other known school song is "Wave the Old Gold," written by Charles A. Boyle, who came to the normal school as professor of music in 1894. Boyle and his wife, Hattie, a music instructor, resigned in 1908 to establish the Emporia School of Music.

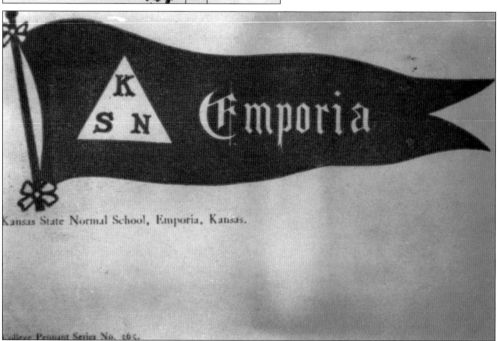

Kansas State Normal School, Emporia, Kansas.

College Pennant Series No. 265.

This image is one of several of Kansas State Normal School pennants printed on postcards. Other postcards show a gold pennant with a photograph of the 1880 main building embedded in the center. From humble beginnings on the second floor of a borrowed school building, the Kansas State Normal School was evolving into one of the best teacher education institutions in the country.

26

Two

A CAMPUS EVOLVES

By 1915, the Kansas State Normal School campus situated on the north side of Twelfth Avenue was quite a sight to behold from the central downtown business district. By then, there were five major buildings sprouting on the eastern edge of the Flint Hills prairies. Enrollment was more than 3,000 students during the school year and more than 2,000 during the summer. There were three main divisions of the school—the training school, the secondary school, and the college.

Thomas W. Butcher was chosen as the eighth president of the Kansas State Normal School on April 11, 1913. He held the position for 30 years, until his retirement in 1943. During his tenure, the school saw great growth in enrollment, the curriculum, and the landscape of the campus. During Butcher's term, Kansas State Normal School became one of the first normal schools recognized and accredited by the North Central Association. In 1923, Kansas State Normal School was renamed the Kansas State Teachers College. Butcher Children's School was named in his honor.

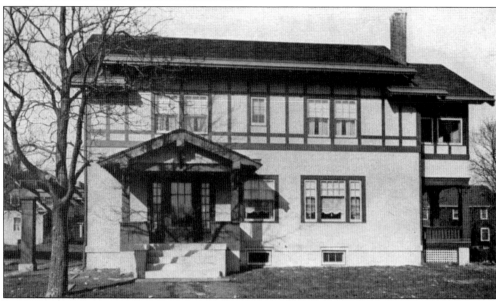

On September 12, 1916, the Butchers moved into their new Tudor Revival residence located five blocks west of the campus. The Butcher family would call this home for nearly 45 years, until Butcher's death in 1947. It was here they raised their three children—Thomas P., who became an Emporia physician; Walter P., who later became a professor of history at Emporia State; and Mary Louise, who married C. Stewart Boertman, professor in the social science department at Emporia State.

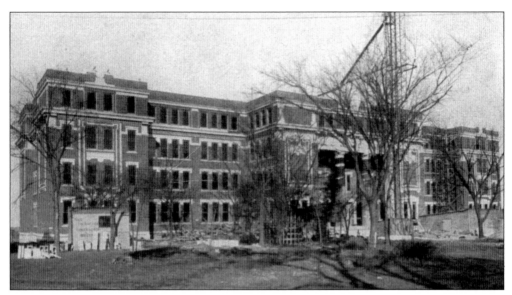

By 1910, no part of the old main building was being used for its original purpose. Following several inspections, the building was declared unsafe. In 1915, the legislature appropriated $175,000 for a new administration building. Completed at a cost of $250,000, the new four-story building was occupied in June 1917. The structure was 268 feet in length and contained 90 classrooms and an auditorium, which could seat 2,500. Although an elevator was included in the planning, the appropriation was not sufficient for this service. It was named the Preston B. Plumb Memorial Building in honor of Emporia's founding father.

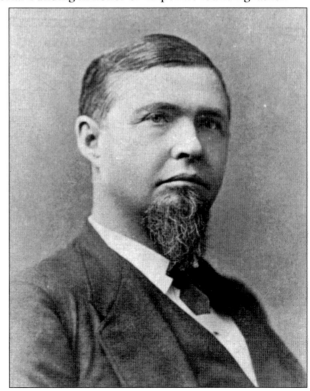

Preston B. Plumb was the only member of the Emporia Town Company to remain in Emporia after its founding on February 20, 1857. Plumb dedicated his life to serving Emporia and the state of Kansas. In addition to being a journalist, he studied law and was admitted to the bar in 1861. In 1862, he entered the Union army, in which he earned the rank of lieutenant colonel. He served in the Kansas House of Representatives for two terms. Plumb was elected to the US Senate in 1877, serving in that capacity until his death in office in 1891.

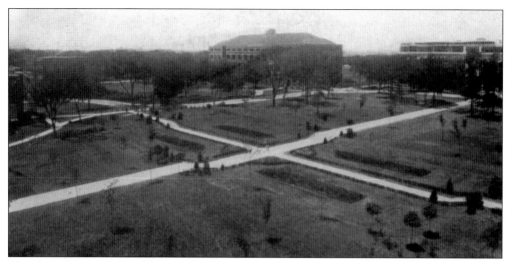

The demolition of the old main building left a large hole in the middle of the campus landscape. It was decided this would be an excellent place to establish a garden. Known to everyone as the Sunken Garden, the excavated basement was filled in to a depth of three feet and 150 feet in length. In the center, a sundial and monument were built with funds donated by the senior class of 1918. On the face of the dial are the words "Grow old along with me, the best is yet to be." Years later, when a fountain was built in the center of the garden, the sundial was moved to a location near the library. This image shows the garden in 1920.

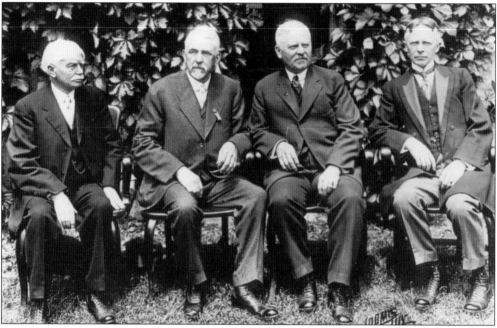

June 1, 1915, was designated as "Anniversary Day" in celebration of the 50th year of the Kansas State Normal School's existence. Elaborate plans were made to entertain the many friends and returning alumni of the school. Three of the four living ex-presidents were also present and participated in the celebration, as shown in this image. From left to right are Judge Lyman B. Kellogg of Emporia; Albert R. Taylor of Decatur, Illinois; Jasper N. Wilkinson of Muskogee, Oklahoma; and then Kansas State Normal president Thomas W. Butcher.

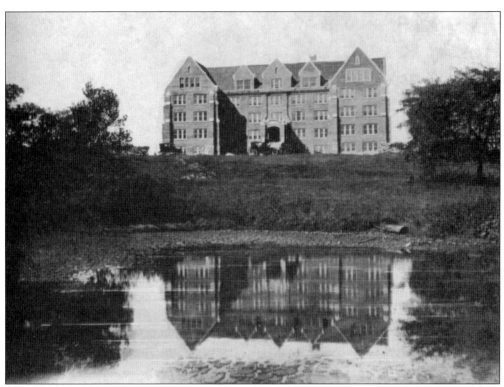

The first dormitory for women was opened on February 1, 1924. The building was named Abigail Morse Hall in honor of Abigail Morse, who had become the preceptress of the normal school in 1873 after the death of her husband, Rev. G.C. Morse. The building was situated about 300 feet north of the Plumb Memorial Building. The fireproof building was equipped with lavatories in each room, tubs and shower baths on each floor, and closets and two or more windows in each room.

Morse Hall Annex was added to the campus in 1926 after the legislature approved funding for the new Music Building. The Thomas house, located at 108 East Twelfth Avenue, was the largest of five houses on a strip of land between Twelfth and Thirteenth Avenues next to Market Street. The house was moved to the slope of Lake Wooster and renovated for additional dormitory space for women at a cost of $3,000. It could accommodate 14 students.

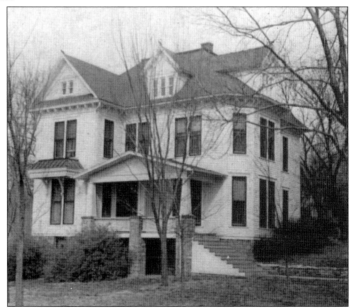

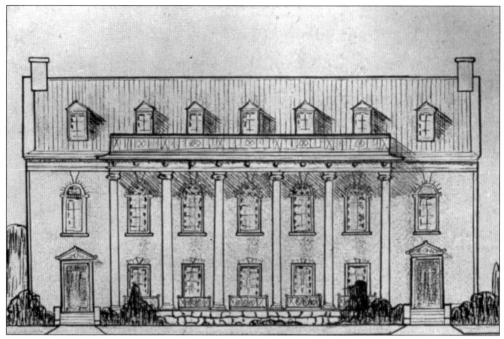

Although the students of the Kansas State Normal School had voted to purchase chimes in May 1919 as a memorial to the 589 men who had enlisted in World War I and the 21 students who had lost their lives, the plan was changed in 1921 to construction of a student-alumni building. In 1922, a campaign was launched to raise $250,000 for the building plus an athletic stadium and a pipe organ. In August of that year, the State of Kansas issued a charter to the Memorial Union Corporation. The charter was the first issued to a college institution west of the Mississippi River. This image shows one of the architectural drawings proposed for the Memorial Union.

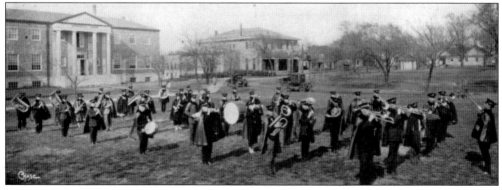

In June 1923, the City of Emporia pledged $50,000 to the Memorial Union Fund. $44,000 was made available at an early date, so ground was broken for the Memorial Union Building on November 23, 1923. By the close of 1924, the building was under one roof. It was located between the Plumb Memorial Building and the cafeteria. This 1925 image shows the marching band in front of the new Union Building shortly after it was completed.

Although the Memorial Union was fully occupied in 1925, the building was not complete. The addition to provide a recreation room for social purposes, such as school parties, large meetings, and other activities with large groups, had not been built due to lack of finances. Alumni and friends rallied in 1926 to raise the estimated $50,000 cost to make the addition a reality. On May 10, 1929, a grand reception was held to commemorate the opening of the addition, which today is known as the Colonial Ballroom. (Courtesy of University Photography.)

Wooster Lake began as a small pond in 1904–1905. It was not until the fall of 1917 that the lake took the form and look it has today. At that time, many campus improvements were being made through a special appropriation from the legislature. One of the improvements was the building of a dam in a ravine behind the administration building using brick and mortar from the demolished old main building. The lake was named after Prof. L.C. Wooster, who used the smaller lake to teach about different fish and plant life.

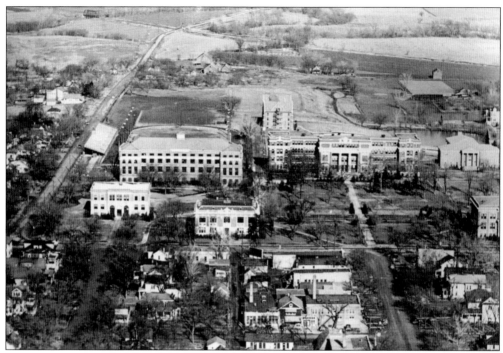

This c. 1928 aerial view shows the Kansas State Teachers College campus five years after being renamed. In center of the campus are Plumb Hall and the Sunken Garden. To the far right is the Memorial Union, and to the upper right is the Norton Science Hall. To left of Plumb Hall are Kellogg Library and the training school, with the larger building being the Physical Education Building. To the north of the Physical Education Building are the grandstands and playing field. Behind Plumb Hall are Morse Hall, Wooster Lake, and the power plant.

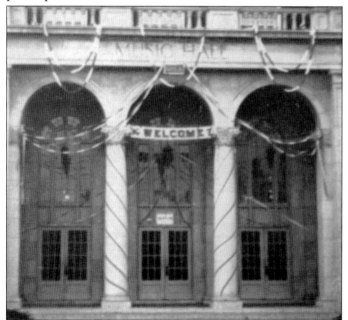

The need for a larger building for the music department was finally met in 1925 when the legislature appropriated $150,000. The building was ready for use in 1926. There were both large and small rehearsal rooms along with a 400-seat auditorium for recitals and concerts. In 1956, the building was named Beach Music Hall in honor of Frank A. Beach, who had served as head of the music department until his death in 1935. This 1938 image shows the building decked out for a seasonal event.

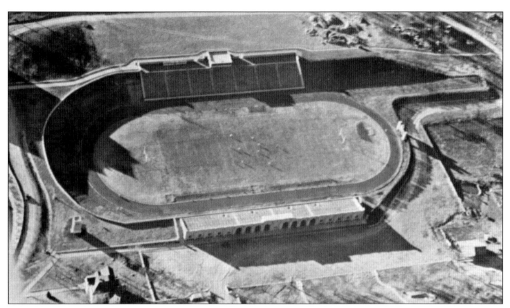

Work began in April 1936 for a new stadium as part of a Works Progress Administration project, a program to help unemployed Americans obtain jobs during the Depression years. It was completed in time for the first home football game in 1937. The cost was $155,000. Under the east side of the stadium, which could seat 3,000, were locker rooms, showers, storerooms, and lecture rooms. The west-side section was completed in 1938 and provides seats for 4,000.

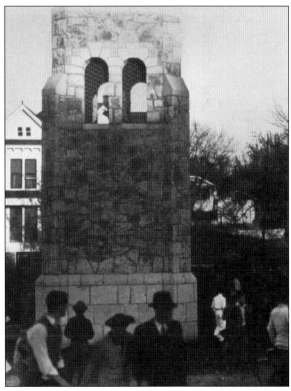

Shortly after the completion of the stadium, an idea for the bell that had been saved from the old main building surfaced. A bell tower next to the stadium would be an excellent way to sound the victories of the school. The bell tower was completed in 1939 but remained silent—for there were no victories. The students soon dubbed the tower "Silent Joe." It is not known for certain where the name Joe came from, other than the name given to the average college student. Although named Silent Joe, the bell often sounds the victories of Emporia State football games.

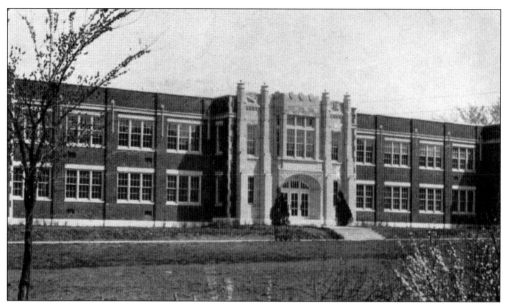

In 1927, the legislature appropriated $150,000 for an elementary training school and its equipment. In April 1929, about 320 children walked from the old training school on the west end of campus to the building on the east side of campus. It was designed with all the latest ideas in modern elementary education. Roosevelt High School was moved from the fourth floor of Plumb Hall to the newly redecorated old training school.

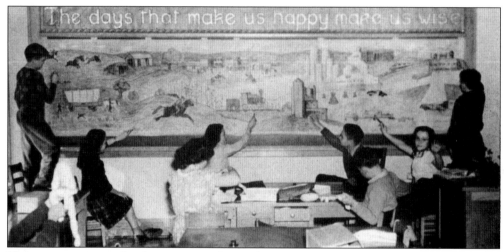

The new training school was not only aesthetically appealing on the exterior, but its interior was also appealing and functional. The kindergarten room contained a fireplace, and throughout the building were sets of double classrooms, a library, and medical and psychological testing rooms. The playground was equipped with swings, a baseball diamond, and sandpiles. This image shows a painting in one of the classrooms of a pioneer/agricultural scene, with the classic quote from the British poet John Masefield: "The days that make us happy make us wise."

Three

GETTING EDUCATED

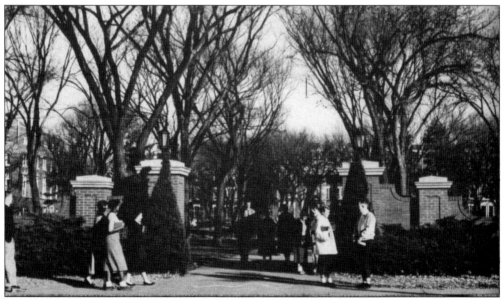

Not long after the first building of the normal school was constructed, it was surrounded by a white picket fence with hitching post in front. Entrance onto the campus was through a large swinging gate at the head of Commercial Street. In the spring of 1931, brick pillars were constructed at the front of the campus as shown in this image. The pillars were partly funded through money left by the senior classes of 1930 and 1931. Later, the pillars and gates were removed to create the Kellogg Circle Drive.

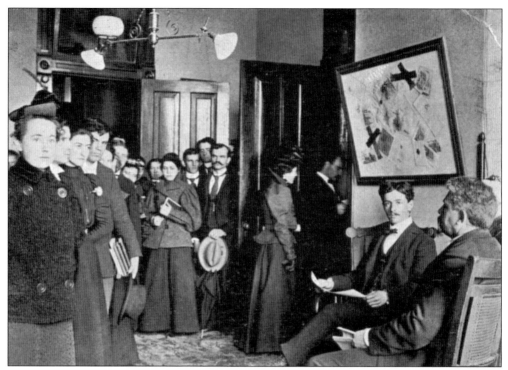

In 1898, the enrollment at the normal school was nearly 2,000. At that time, the only building on the campus was the main building. Two large sets of stairs led to the main rooms in the building. Through these doors, the students would enroll and begin their first day of classes. This image shows students with books under their arms waiting for the professors to direct them to their classes.

By the mid-1950s, enrollment had doubled at Kansas State Teachers College. Incoming students had to stand in line to enroll in classes and also went to the Colonial Ballroom in the Memorial Union to learn where their classes would be held. Long dresses and flowery hats had long been discarded for shorter dresses, bobby socks, and the obvious freshman beanie.

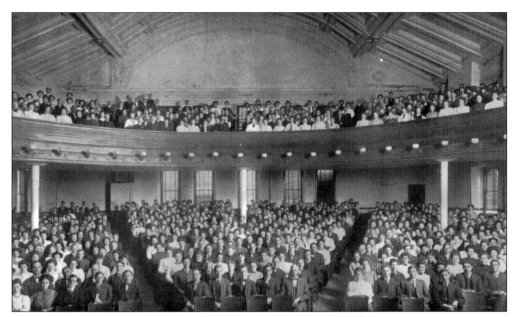

General assemblies were held more often in the early years of the normal school. These were times when the entire student body and faculty would gather to hear announcements from the administration or to partake in a special event. The assemblies were held in Albert Taylor Hall, as shown in this image from 1909.

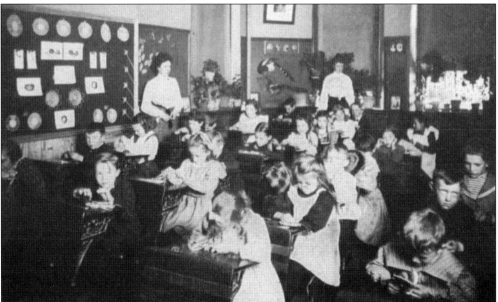

The training school was the key to success for Kansas State Normal School. The model school provided the opportunity to train young men and women to become teachers. The students were most often local children from the community who paid a small tuition to attend the school. Most of the school's instructors had a designated room similar to the elementary schools today. In this image, the children are studying in the room of Achsah Mae Harris, who taught elementary reading. Harris was also a poet whose work was published in Kansas journals.

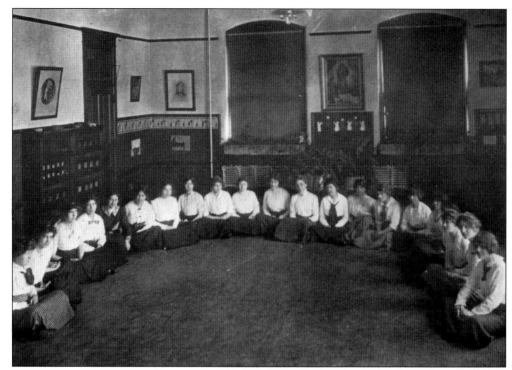

Teachers were always in demand for the elementary grades in Kansas and throughout the country. Rural families were often large, as the children would help with the many agricultural tasks so the family could make a living. Even with all the chores that had to be done, the children went to at least eight grades of schooling. This 1914 image shows a circle of normal school students who would soon be kindergarten teachers.

By 1915, the Kansas State Normal School was being recognized as a leading teacher institution. Students from around the country were coming to Emporia to become teachers, as the demand was always great. For many years, the rule was that a woman teacher could not teach after she got married. This photograph from 1915 shows 100 of the 300 teachers being educated that year.

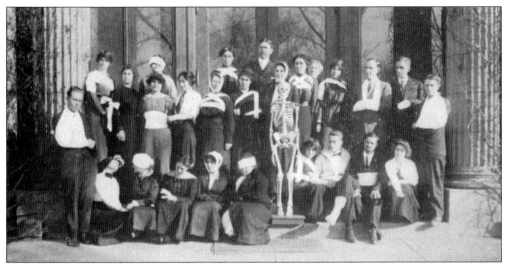

Teachers had to be qualified not only to teach many subjects at different grade levels but also had to know how to take care of emergencies. Many teachers often were in one-room schoolhouses in the country where assistance was not readily available. This photograph of a 1914 first aid class shows an example of the different types of medical needs a teacher might have to take care of during the school year. The skeleton was obviously used to help identify the various bones of the body.

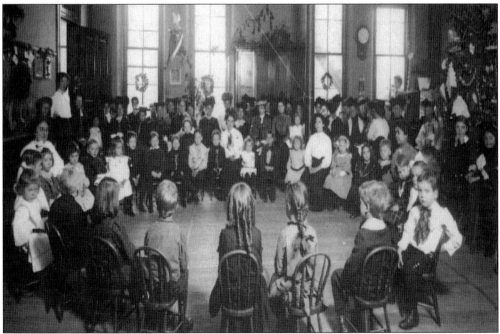

Seasonal celebrations were an important part of the education system. These celebrations provided an opportunity for the children to learn classical stories, give recitations, perform, or wear special costumes made by their mothers. The celebrations were also social events for the community where families visited, relaxed, and had fun. This image shows a young circle of children at the training school during the Christmas season ready to present a program to their mothers.

Students were encouraged to develop their talents and skills in the performing arts. Music soon became one of the most outstanding programs within the normal school. Names such as Charles Boyle, Marcellus Grady, and Frank Beach became synonymous with the normal school. This image shows the 1920 Roosevelt High School band. The normal high school had just been renamed in honor of former US president Theodore Roosevelt.

Industrial arts training was a standard for all normal schools with training programs. Teachers and student teachers would educate and manually train students in various trades that could eventually lead to jobs. This image from 1920 captures both boys and girls learning trades in basket weaving, woodworking, and sketching.

Kansas State Teachers College became renowned for its science education program through the teaching and work of Ina Borman, instructor at Butcher Children's School. Borman was a member of the faculty for more than 40 years. As a member of the International Science Fair Council, she encouraged school science fairs throughout the state. Her deep love for science and children caught the eye of the editor of *Life* magazine. The January 7, 1957, issue of the magazine features a story on a new elementary laboratory she had designed.

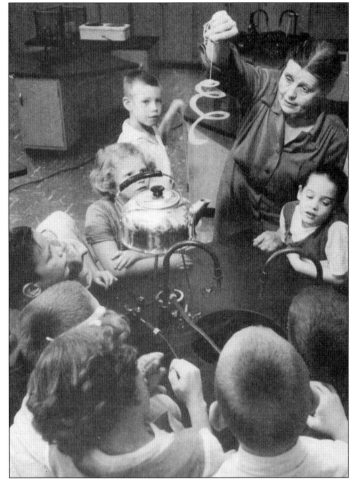

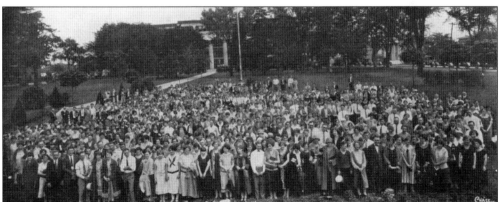

Prof. M.A. Bailey, who taught mathematics and Latin to advanced students, organized the first summer school in 1891, so students might graduate at an earlier date. Fifty-three students were enrolled for 1891. In 1892, three other faculty members offered courses for a 10-week duration, which were taken by 166 students. By the mid-1920s, summer school enrollment had increased to 3,500 students. This image shows summer school students posing in front of Plumb Hall.

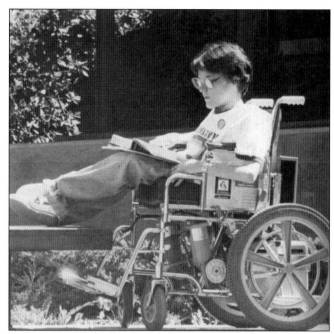

A handicap-accessible campus became one of the focuses of Pres. John E. King during his tenure from 1953 to 1966. Sidewalks became smoother and wider. Ramps were built for wheelchairs. Signs were installed to ensure the disabled were able to move around campus to get an education like anyone else. This photograph is indicative of the opportunities available at Emporia State.

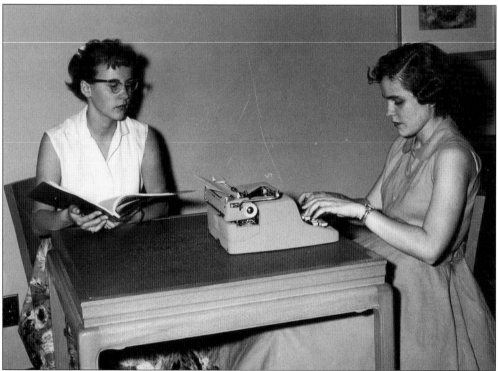

Many young people soon discovered the friendliness and helpfulness of the Emporia campus to those with disabilities seeking an education. As the federal government was passing new laws and regulations to assist those with disabilities, the Kansas State Teachers College quickly adhered to them. Here, a young blind student is learning to type using a Braille typewriter with the assistance of another student.

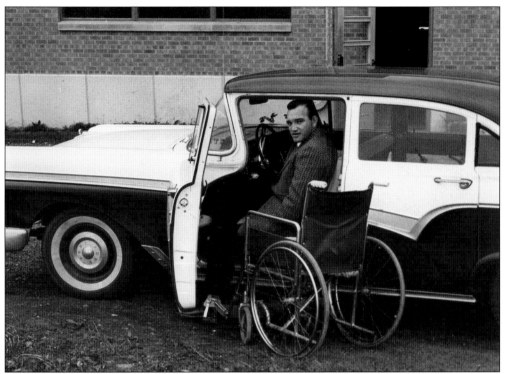

Not only was the teachers college a leading institution for student handicapped accessibility, but it was also a leader in employing those with disabilities. In 1965, Bill Scales was hired as a faculty member in the Office of Rehabilitation Counseling. He later served as assistant director of counseling services. This image shows Scales getting into his custom-made car, which allowed him to drive by himself.

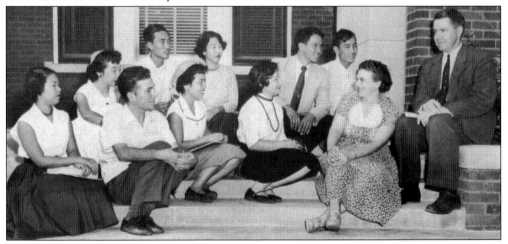

During John King's tenure as president, enrollment grew sixfold. Part of the enrollment increase was due to the returning soldiers from World War II and the American economy following the war. King also encouraged international students to enroll at Emporia, where they could receive a good education at a small academic college. This photograph shows President King and dean of women Ruth Schillinger with a group of international students on campus.

Many female students attending college in the post–World War II years majored in home economics. Whether becoming teachers or just learning how to manage a home, students were offered training in consumerism, home environment, and family relationships. Today, home economics is known as family and consumer science. This 1952 class of students is being taught proper cooking methods.

As is known, not all learning takes place in the classroom. Many classroom assignments involve study and research at the library. By the mid-1940s, the Kellogg Library built in 1904 was stretched to its capacity and literally falling apart. There were areas in the library where a book could be stuck through the crack in the ceiling. In 1950, a new library was built and named in honor of William Allen White. This new facility provided state-of-the-art equipment such as this microfilm reader being used by a student in 1953.

Creating a positive living environment on a campus with a wide range in age population, family backgrounds, and cultures is no easy task. Throughout the years of Emporia State, there have been many good men and women in student affairs to create this environment. John R. Webb is shown in this photograph when he was serving as vice president of student affairs and support services. Webb began his association with ESU in 1959 serving many years as dean of men. Webb Hall in the Memorial Union is named in his honor.

Two of Emporia State's most distinguished faculty are Thomas and Mary Winstead Bonner. In 1960, Thomas was hired as the first African American faculty member at Emporia State. He taught mathematics. Mary joined the ESU faculty in 1964, teaching in the Department of Administration, Curriculum, and Instruction. Both of the Bonners retired from ESU in 1986, but their support of the university and its students continued. The couple established the Bonner-Bonner Mathematics Scholarship and the Bonner & Bonner Diversity Lecture Series.

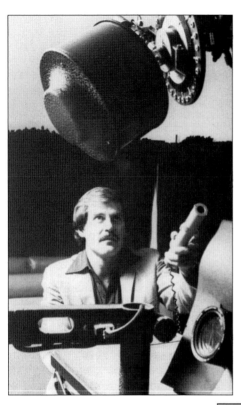

Peterson Planetarium has provided quality astronomy programming since 1959 for Emporia State University and the greater Emporia/Lyon County community. About 50 percent of the programs are presented to school-age children and the other 50 percent are for direct support of instruction in several courses in the physical sciences. The planetarium was named in honor of Oscar Peterson, who served as chair of the mathematics department from 1928 to 1963. This image shows DeWayne Backhus, professor in physical sciences, operating the planetarium equipment.

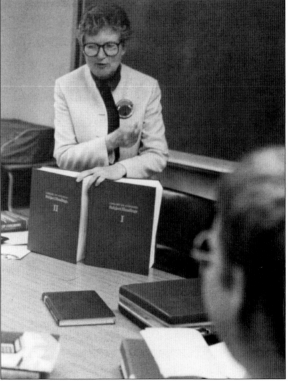

In 1902, Kansas State Normal School was the first school west of the Mississippi River to offer courses in library science. In 1932, the American Library Association granted accreditation to the school. A master of science degree program was approved in 1951 by the board of regents, and a doctoral program in Library and Information Management was approved in 1993. Here, Prof. Florence DeHart is teaching future librarians the skills of cataloging books.

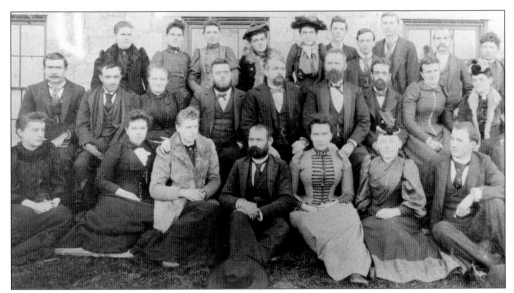

In his 1883–1884 report to the board of directors, President Taylor made a plea for an increase in faculty. The rooms were filled to capacity, and there were not enough instructors to instruct those who wished to enroll. Taylor pointed out that the enrollments of Kansas University and the Agricultural College at Manhattan were smaller than the enrollment of the normal school. However, they had four to five more faculty members. This image shows the faculty during the presidency of Albert Taylor.

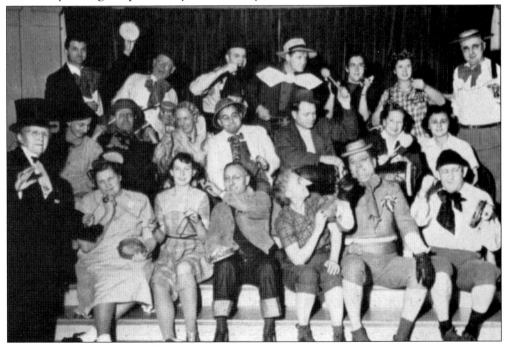

Although Emporia State faculty members are serious about giving students the best education possible, they also enjoy having fun with the students and with one another. This image, titled *The True Character of the Faculty*, was taken in 1949. Most likely, this was a special event being held in the Children's Training School.

The normal school began with one instructor, principal Lyman B. Kellogg. Seventy-five years later, in 1938, there were 120 instructors. With Pres. Thomas Butcher as a successful leader, the faculty had grown not only in numbers but also in importance as a friend to the entire student body. President Butcher had much respect for the faculty, as this image shows them at the men's picnic on Butcher's ranch.

Faculty members have always been ready to sponsor a party, advise a social or education group, take students on trips, or give advice as personal friends. Homecoming is not just to see old classmates. Homecoming is to see the faculty who had also become friends. Faculty women are seen in 1938 holding one of their regular meetings.

50

Physical fitness and health are an integral part of a general education. Classes were taught at the normal school to help students realize the importance of maintaining a healthy body. Supervised by student teachers, daily exercises were completed by the model-school students. Continuing with the normal school philosophy of maintaining healthy bodies, Prof. C.K. Turner, instructor in health education in 1940, poses with a smile on his face and a hand on the hip of his favorite skeleton.

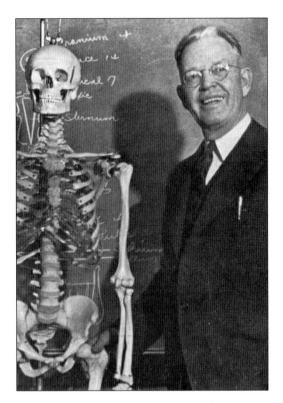

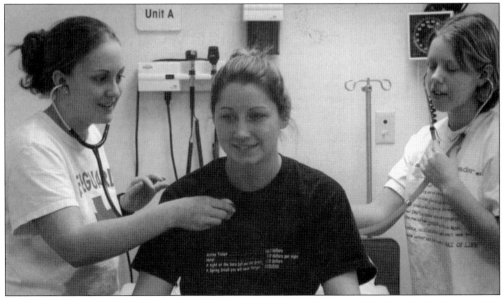

The Kansas Board of Regents approved a joint program between ESU and Newman County Memorial Hospital to offer a bachelor of science degree in nursing in 1989. The Newman Regional Health center has earned a reputation as an exemplary clinical and educational site for students pursuing health-related professions. The ESU/Newman Division of Nursing is located on the hospital campus. Students are seen in this image learning how to use a stethoscope.

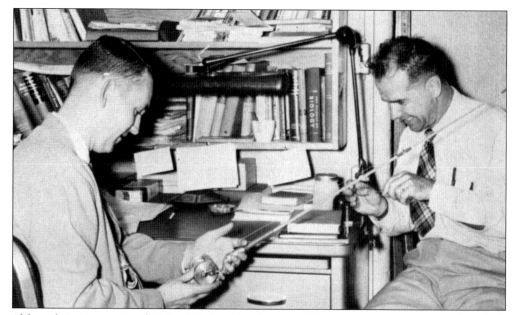

Although it appears Prof. Robert Boles (right) and a fellow instructor are preparing their fishing rods for an afternoon at their favorite fishing hole, they are actually discussing methods of seining in this 1961 image. ESU has a long history of excellent research and instruction in natural history, fisheries and wildlife biology, ecology, and organismal biology.

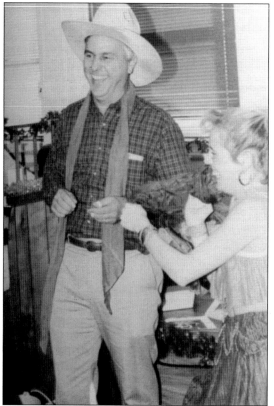

Situated in tallgrass country of the Great Plains, Emporia State University emphasizes the study of the grasslands as one of its primary responsibilities to Kansas and the region. When the Kansas Board of Regents authorized the Center for Great Plains Studies in 1977, that sense of responsibility became an exclusive mandate for ESU. Here, Jim Hoy, an English professor, Flint Hills native, writer, and one of the Center for Great Plains directors, sports his cowboy image at a reception in his honor.

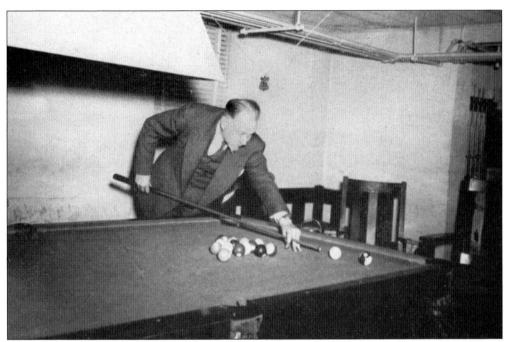

The faculty men must also have their recreation. While the students beat a path to the Memorial Union, the faculty men retired to their club. In this image from 1947, George R.R. Pflaum, professor in forensics, takes aim on the pool table. Pflaum came to Kansas State Teachers College in 1923 and served on the faculty for more than 40 years. The Pflaum Lecture is named in his honor.

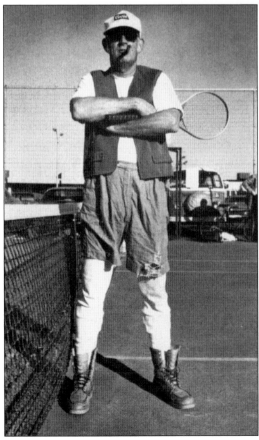

During October 1978, Emporia State faculty demonstrated their concern for women's sports. Their concern was seen in the form of a challenge tennis match with the Emporia State varsity women's tennis team. Each faculty member contributed $90 for the right to play. The varsity women obtained sponsors from the campus and community, with all funds going to women's sports scholarships. This image shows John Peterson, dean of liberal arts and sciences, in his special tennis gear.

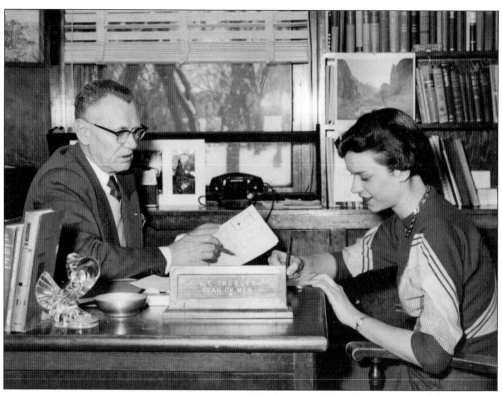

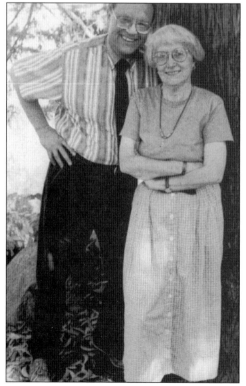

Students, such as this one in 1946, always welcomed the counsel and advice of V.T. "Vic" Trussler. His personality and straightforward manner enabled him to come into close contact with the students on campus. Following World War II, his major concern was counseling returning veterans. Trussler served as head of the physical education department and was a respected athletic coach before assuming the role of dean of men.

Gerritt and Barbara Bleeker came to Emporia State University in 1969. Gerritt came as a teacher because he wanted to be an educator at a school that prepared people to teach. Barbara came as a graduate student. After teaching in public schools, she joined the English faculty in 1986. For many years, they team-taught in the English department, wrote a column on children's books for the newspaper, and donated their extensive children's book collection to the Teachers College Resource Center for the training of future teachers.

Four

CAMPUS LIFE

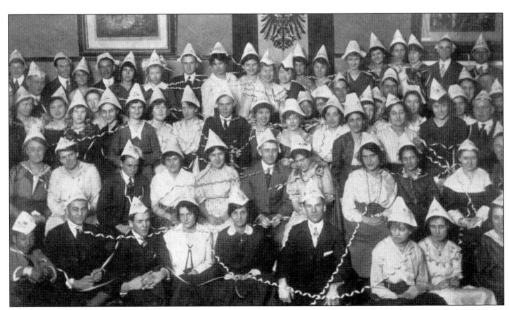

Students from normal school days to the present have always found ways to entertain themselves and the community through social and cultural functions, recreational activities, or fundraising events. Members of Der Deutsche Verein (the German Club) are shown here in 1917 celebrating the New Year regaled in hats and streamers. The purpose of the club was social and educational.

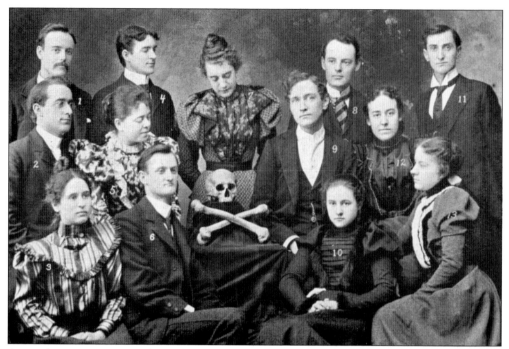

A popular superstition in the 19th century centered around the number *13*. The superstition grew around the 12 disciples and Christ at the Lord's Supper. It was believed that if 13 people were seated around a table, one would die within a year. In the 1880s, clubs across the nation were formed to debunk the superstition. This 1898 image shows the Thirteen Club posing with a skull and crossbones as its symbol.

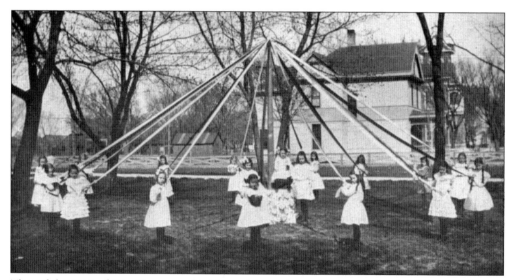

The celebration of May Day was a highly anticipated event among schoolchildren each year. A maypole would be constructed with long streamers for the children dressed in their best to dance around. Often, the maypole dance was accompanied by other dances as part of a presentation to the public. This 1904 image shows the delight of the young girls from the primary training school.

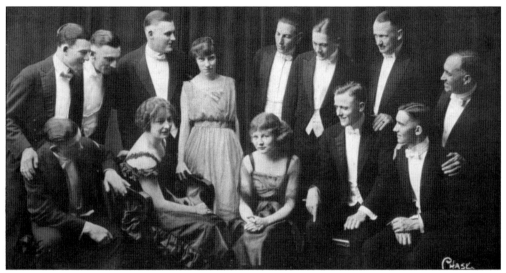

The Gilson Players, as seen in this 1921 image, was a group of amateur dramatic artists from the faculty and students of the normal school of expression formed in 1918. The group was named after Franklin L. Gilson, professor of public speaking and expression. Besides presenting at least three plays during the year, members traveled the state performing in other cities. These experiences provided them training as good future teachers and brought good plays to audiences who might seldom have an opportunity to see them.

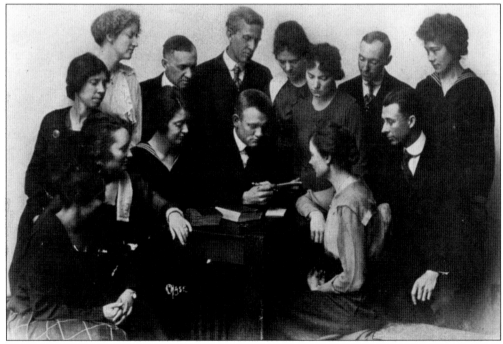

The Scribblers' Club was organized in 1919 as a direct result of the interest created by the writing of the play *When My Ship Comes In*. The club was composed of both students and faculty vitally interested in writing who wanted constructive criticism in the development of their literary abilities. Membership in the club was obtained by the presentation of a manuscript.

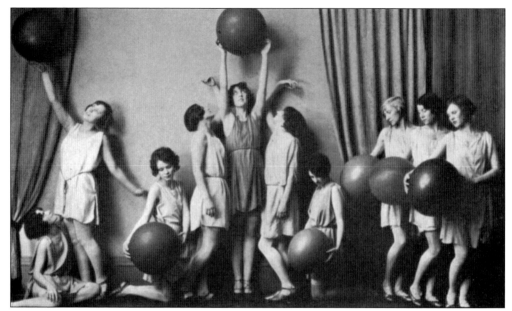

In 1928, about 600 students were enrolled in the 12 dancing classes offered by the women's physical education department. A group of girls picked from the best dancers would meet to study dancing. This group of 24 girls was known as the Rhythmic Circle. The dancers would perform in Emporia and the surrounding communities. This image shows the dancers doing the "balloon dance."

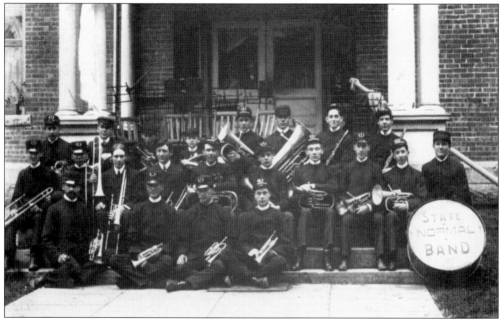

Always in high demand, the Kansas State Normal School band was one of the most popular instrumental groups. Besides playing at the school's athletic events, the band would often give performances in the community and surrounding areas. The band was also a lead attraction in parades. This image shows band members in their uniforms ready for a performance.

The music department's Harmony Picnic in Soden's Grove reflects the following comments from the 1920 *Sunflower* yearbook: "The professional music student may vivisect a melody and discover scientific harmony, but the sort of harmony that pervades the Sings, Picnics, Glee Club, Treble Clef, the Orchestra and all other musical organizations and events make the strongest appeal to the unsophisticated student at Kansas State Normal School. The kind of harmony which leads to cooperation is always evident, in any event in which the music folks, faculty and students alike are concerned."

Inez Plumb

In 1925, the organizations of the campus and the *Sunflower* staff picked 25 of the best-looking girls on the normal school campus. Their pictures were sent to Karl Fitzer, an artist in New York City, who picked the six best-looking girls of that group. Inez Plumb, the daughter of George and Ellen Plumb and niece of Preston B. Plumb, was among the six chosen.

Three queens were chosen to rule on the normal school campus in 1920. There was the beauty queen, Marguerite Scott, from Topeka; the popularity queen, Virginia Haynes, from Emporia; and the queen of cleverness, Ruth O'Farrell (pictured), also from Emporia.

The normal school also recognized men of high character, good looks, and skills. Ellsworth C. Dent of Council Grove was selected in 1922 as the "Most Domesticated Man." He was a member of the Student-Alumni Council, the K-Club, the Track Squad, the Phi Kappa Delta honorary forensic fraternity, the Sigma Tau Gamma fraternity, and the debate squad.

In recognition of student achievement, the *Sunflower* staff in 1937 held an election to choose outstanding students on campus in a king and queen contest. The royalty were elected on the basis of beauty and handsomeness, personality, neatness and dress, and leadership. The results were extremely close, but Evelyn Wenrich of Oxford and Wilbur Daeschner of Emporia won the titles of the Sunflower Queen and King.

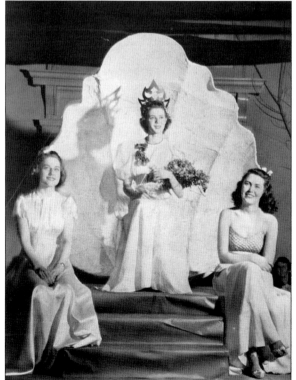

The origins of the Beaux-Arts Ball are traced back to the 19th-century French Ecole des Beaux-Arts in Paris, where the very first ball was hosted. The theme of the ball asked for creativity and imagination in costumes and decorations. At Kansas State Teachers College, the Beaux-Arts Ball was only held during the late 1930s and early 1940s. The ball was more of an opportunity to have a social event with dancing. This image shows the queen of the ball and her attendants in 1940.

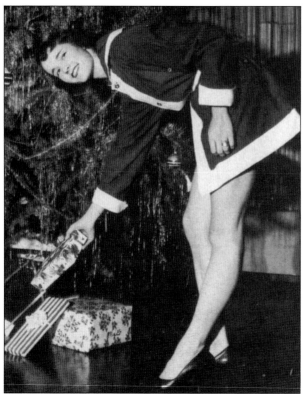

In 1953, Eartha Kitt recorded the popular song "Santa Baby," about a woman wanting extravagant gifts for Christmas. In 1954, the KSTC student body decided to identify its own Santa Baby. This image shows the unidentified Miss Santa Baby checking out the gifts under the Christmas tree.

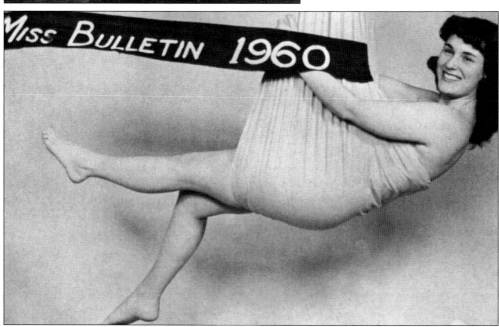

The school hosted the Miss Santa Baby Contest for several years, but the *Bulletin* sponsored a Miss Santa contest. The sororities, fraternities, and Morse Hall nominated the contestants. During the 1960 contest, the candidates were photographed as a calendar of the month contestant. Pictured is Miss January, De Ann Dewey. Marty Ward won the contest.

In 1936, the title of "Peggy Pedagog" was bestowed upon the homecoming queen. Edwin Brown, a former faculty member, coined the term because he thought there were too many "queen" titles and wanted something more catchy and meaningful. His wife was known by the name "Peggy," and Pedagog (meaning "teacher") just flowed well. The first Peggy Pedagog was Wilhilma "Billie" Engler, who went on to become a member of the English faculty.

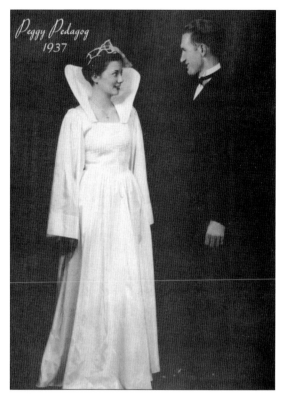

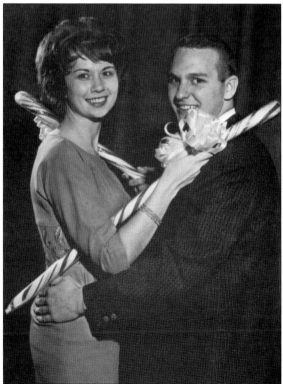

Associated Women Students, a newly formed organization in 1962, sponsored a new type of Christmas royalty that same year. They were called the Candy Cane Couple. Each organized group on campus could nominate two people. Fraternities nominated independent women and fraternity men, and sororities nominated either Greeks or independents. The candidates were judged, and 10 finalists—five men and five women—were announced. Shown here are the Candy Cane Couple for 1963, Sara Tuley and Ben Doughty.

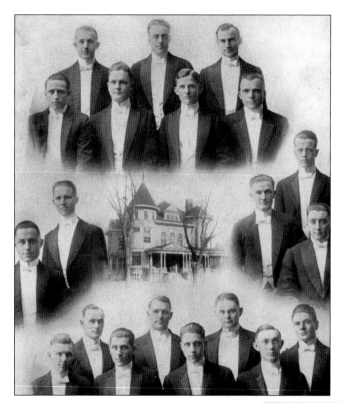

The Phi Sigma Epsilon fraternity was founded on February 20, 1910, at Kansas State Normal School. With much opposition to secret societies, Phi Sigma Epsilon had to exist as an underground organization until 1912. The fraternity was considered an outlaw organization and frowned upon by many of the college authorities and citizens. However, the fraternity's willingness to cooperate and its program of scholastic and social improvements soon won support and admiration. Finally, in 1913, Phi Sigma Epsilon was officially recognized on campus.

On November 17, 1894, in Ypsilanti, Michigan, nine female students from Michigan State Normal School formed a secret club called JPN. In a nod to the fashion of the day, the letters of this club stood for "Jolly Petticoats Nine." Other JPN members recall the secret meaning as "Just Progressive Normalites." In 1897, the JPNs transformed themselves into a Greek-lettered organization, Pi Kappa Sigma. The sorority soon found its way to the normal school at Emporia, as shown in this 1917 image.

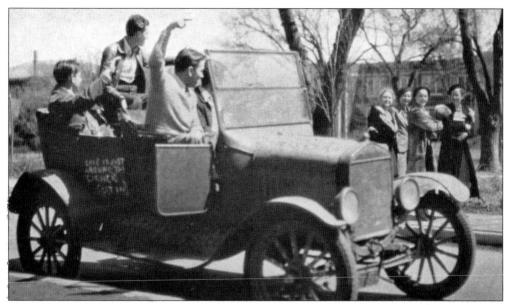

The fraternities and sororities furnish friendships that last a lifetime. Good times are much in evidence at formal occasions and also when small groups meet up for informal chatter. In this image from 1935, fraternity boys are trying to catch the eyes of some sorority girls while driving through Kellogg Circle. The words on the car door read, "Love is just around the corner. Get in."

In fraternities and sororities, pledging is becoming familiar with that organization: learning about every single member, bonding with fellow pledges, and learning about the founding members, the history of the fraternity, and the Greek system as a whole. These 1946 pledges from the Phi Delta Chi fraternity anxiously await some comment as to what the actives might have in store for them next. This was one of several fraternities that reactivated after taking time out for World War II.

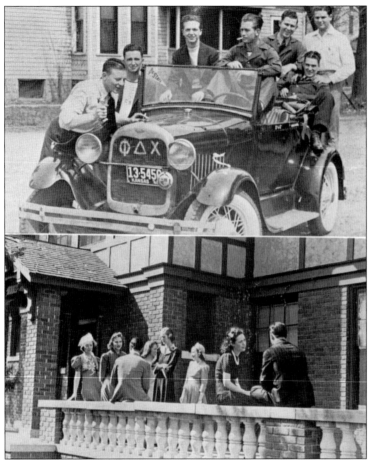

Fraternities and sororities can offer a lot of benefits for college students. Many of these Greek organizations provide off-campus housing for upperclassmen, a fantastic social support network, good leadership opportunities, and a close community to which one can belong during school and after. Nothing could be truer as evidenced by the Phi Delts who hopped on their Ford to visit the Tri Sigs on their veranda at 312 West Twelfth Avenue in the spring of 1940.

The Splash Club was organized in 1928 to provide a swimming organization for advanced swimmers. The program stressed perfection in form and grace. The members enjoyed showing others their skill and gracefulness in the water. The group in this c. 1950 image had recently given a water carnival for the women of the College of Emporia.

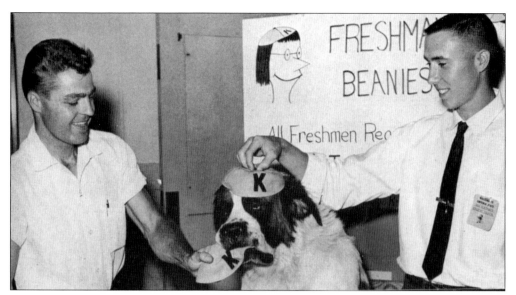

At the beginning of the 1960 school year came a multitude of freshmen. Beanies were seen on the heads of newcomers. If one failed to wear his or her beanie during that week, he or she was sent to K-Club Court for sentencing. As seen in this image, not even Joe the dog was exempt from wearing a beanie. Joe is receiving his beanie from K-Club president Ron Slaymaker.

The K-Club was formed as an organization of men who were regularly enrolled in school and had been awarded the official "K" for their participation in any recognized sport. The purpose of the club was to foster and encourage athletics in school and to advertise the school through its athletic activities. The club also assisted in hosting athletic events. This image shows the members of the 1929 club.

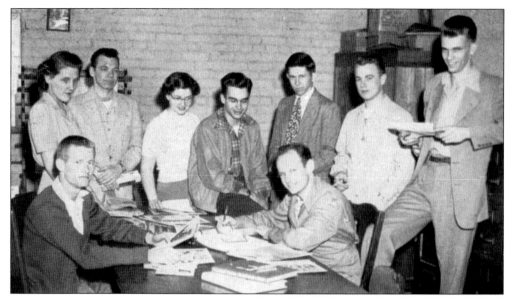

A university yearbook has been published since 1898; however, it was not until 1910 that *Sunflower* became its official name. The yearbook chronicles the year's events and activities. *Sunflower* staff members obtain experience in writing, editing, photography, layout, and graphics, as shown in this image of the 1950 staff.

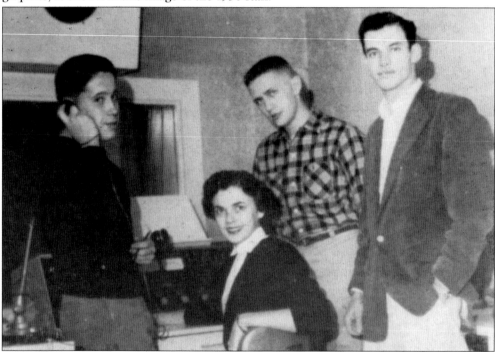

The Federal Communication Commission licensed the station KSTE-FM for unlimited operation on March 10, 1953. The station was a 250-watt frequency modulated noncommercial educational radio station. The primary function of the station was to train students in all phases of radio work. The station was entirely student staffed, as shown here in 1956 with Fred Updegraff, station manager, at the controls.

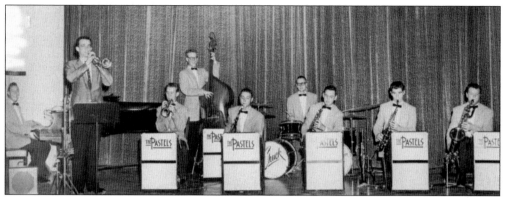

The Pastels, shown in this 1957 image, were a student dance band that performed in the 1950s. Membership in the band constituted a working music scholarship. As members graduated, new members were added. The band made many successful appearances throughout the state in addition to dance dates, convocations, and other activities.

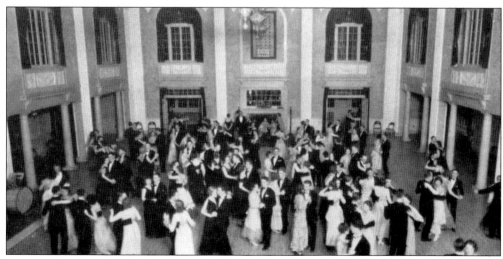

For the first time in the history of the school, an all-school formal took place in the Memorial Union Ballroom on January 9, 1931. The occasion was planned by members of the student council in an effort to get back to the old idea and custom of formal parties at New Year's time. Before the party, a reception was held with Yule logs burning in the fireplace.

Without a doubt, the best place to rest on campus in 1938 was in the Memorial Union. It provided a variety of commercial and recreational services. One of the most popular spots was the Hornet's Nest, where there were plenty of tables and chairs for visiting as well as a soda fountain.

With a growing enrollment, building additions were made to the Memorial Union to accommodate the demands for space by organizations and groups. The student government, activities council, bookstore, *Bulletin*, and health center also called the Memorial Union their home. Key to all of this activity was the information center where students, parents, and visitors could seek directions, mail a letter, and get information about the college. This image shows Grace Atchison manning the information center in 1976.

Food service has always been an important part of campus life. In 1962, the organization provided food for the cafeteria and contract board, training meals for athletes, line dinners, and fountain and snack bar supplies for the Hornet's Nest. Upon request, food services would also provide refreshments for parties, catered dinners, and picnic supplies.

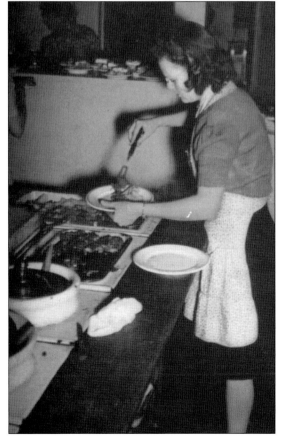

The college Coffee Shop in the Memorial Union, under the management of A.E. McCullough in 1942, was most popular for small steaks and ham sandwiches. The biggest task, of course, was serving dinner for various college organizations. Students also enjoyed the fountain services, as the Coffee Shop would sell at least 200 Cokes per day and about 10 gallons of ice cream. This image shows a student worker preparing food.

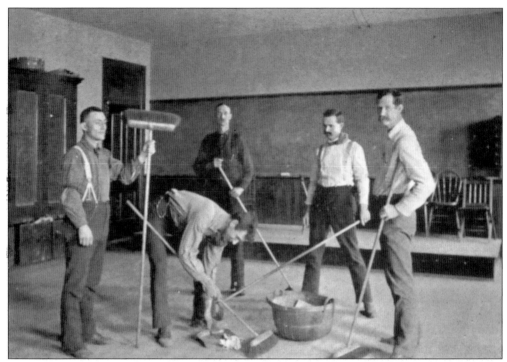

In 1898, the only structure on the campus was the old main building. It was 300 feet long and contained 80 rooms. With an enrollment of around 2,000 plus faculty and staff, there was a lot of activity and movement in one day. To maintain and keep the building clean and usable, a good janitorial force was necessary, as shown in this 1898 image.

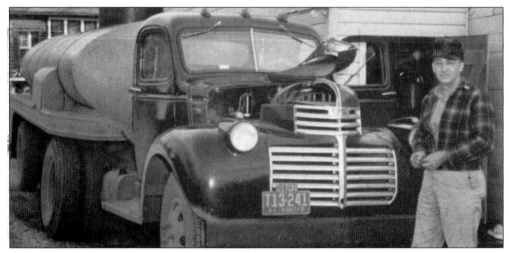

By 1942, the campus had grown from one building to more than ten. To keep a large campus operating requires a lot of manpower, equipment, and fuel. At that time, the power plant was called the heart of the institution in winter and was praised by state officials as the most efficient at any of the state educational institutions in Kansas. Shown here is Ernie Riggs; he drove 47,000 miles a year hauling half a million gallons of fuel oil consumed at the power plant.

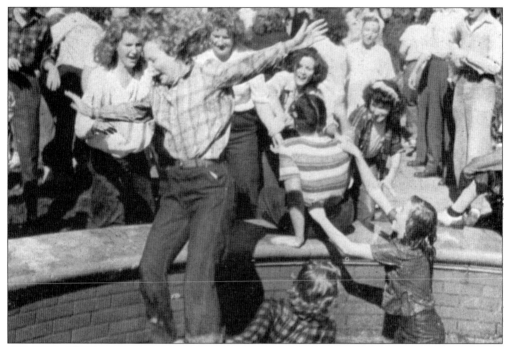

An annual freshmen event was a dunking spree by the K-Club in the Sunken Garden fountain. Both men and women would gather around the fountain to see who might get initiated into the water. As this 1947 image shows, there were equal rights for women when it came to dunking.

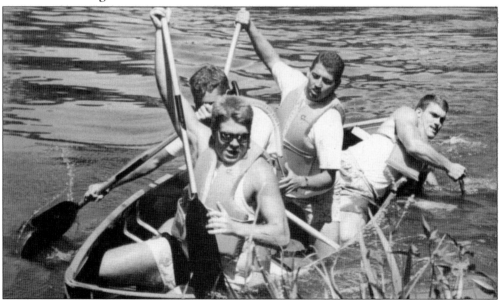

The 17th annual Community-Campus in 1990 began with canoe races on Wooster Lake. The canoe races, barbecue, and football game were a way to welcome students to the university and get the students involved with members of the community. In the end, the Emporia construction workers captured the race with a time of 12:02.66, with the Phi Delta Theta fraternity coming in second at 1:07.21.

To help raise money for needy causes there has been the Penny Carnival where people could vote on their favorite male legs by donating money in a jar. The popular Mr. Legs Contest, such as this one in 1970, was sponsored by the Alpha Phi Omega fraternity.

The residence halls provide a great opportunity for men and women to get to know one another and gain lasting friendships. Residence hall assistants provide guidance and help plan social and recreational events. One of the most popular activities in 1970 was to see how many women could squeeze into a residence hall phone booth.

Onlookers watch in amusement as the first contestant in the potato slide contest whizzes through two inches of cold mashed potatoes during ESU's first annual Potato Olympics in 1990. The Olympics were held to celebrate National Potato Month. Donna Dix, representing the university catering service's "Dicktaters," came out of the event covered from head to toe in the slippery buttered potatoes.

The third annual "Paunch Bowl" took place in February 1964, with an estimated crowd of 800 fans cheering for their favorite players and teams. Proceeds from the bowl games went into the dean of men's emergency loan fund. Bowl events included a dribble derby and two basketball games. Here, the male contestants are taking off in the dribble derby.

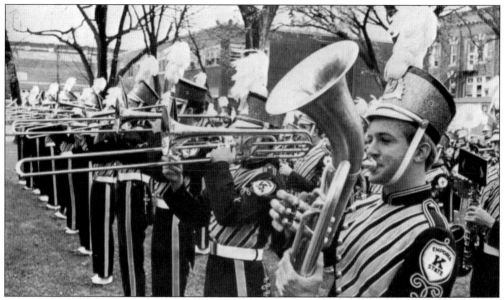

The marching band is one of the most outstanding performance groups on campus. The band carries on the many traditions of high standards, excellence, and pride from the days of the normal-school band. The Emporia Marching Hornets consist of students from virtually every department on campus. Their music and pep can be seen and heard at games, parades, and other special events. This image from 1968 shows the brass line in standing formation.

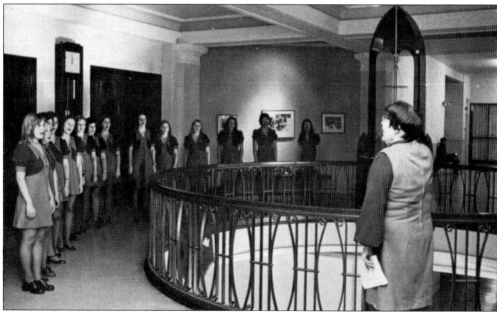

Before the fall semester's final week, Treble Clef brings a little of the Christmas spirit to the students by caroling in the rotunda of Plumb Hall, as shown in this 1975 image. Rosamond Hirschorn is directing the group. Organized in 1913, Treble Clef is the oldest continuous music organization on campus. Seventeen girls are selected for the organization that travels around the community and state performing concerts.

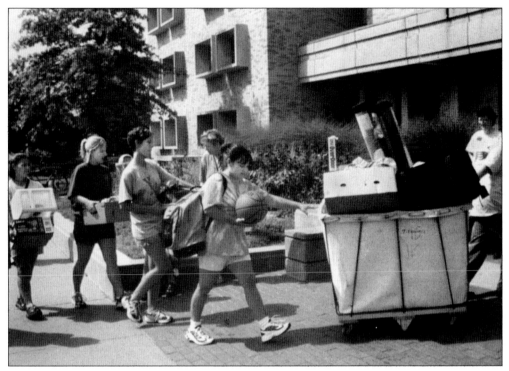

Beginning with the fall 2000 semester, a new tradition was begun when Hornet Helpers arrived at the front doors of the residence halls to help new and returning students move into their living quarters for the coming year. Hornet Helpers include administrators, faculty, staff, fraternity, and sorority members. With many personal items coming from home, the laundry carts are in high demand to help with the moving-in process.

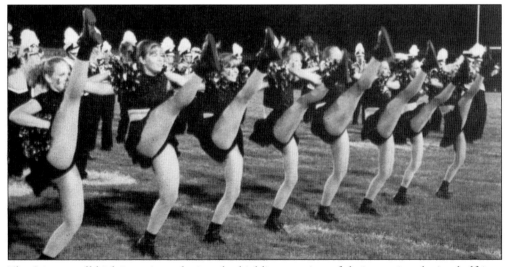

The Stingers all kick in unison during the kickline portion of their routine during halftime of a 1999 football game. This spirit squad, composed of eight women, is to entertain and have fun with the crowds at basketball and football games. To develop new routines and keep the fans entertained, they practice four to six hours a week.

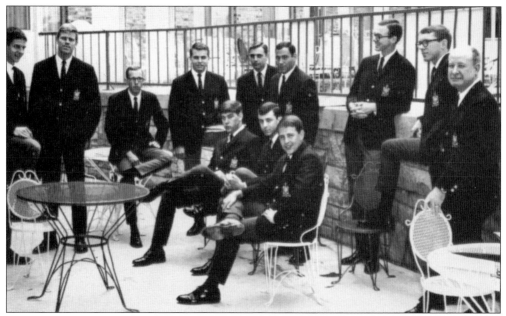

Until the name change to Blue Key Honor Society on February 7, 2003, Blue Key was known as Blue Key International Honor Fraternity, dedicated to service activities. Blue Key members, wearing their blue sport coats embroidered with golden key emblems, provided service to the freshmen talent show, annual prayer breakfast, and the coordination of homecoming and graduation exercises. This 1968 image shows the Blue Key men posing for casual photo following a meeting at the Ramada Inn motel.

SPURS (Service, Patriotism, Unity, Responsibility and Sacrifice), a sophomore honor society, became active at ESU in 1964. In 2006, the national society disbanded, but ESU chose to retain a local group. The society's emphasis is on community service and scholarship. This image shows the 1969 SPURS group posed alongside Wooster Lake.

Black History Week was observed in a variety of ways in February 1968. Seminars, films, guest speakers, and recreational events were held during the week. Organizers of the celebration assisted with closing the information gap and helping African Americans identify with their heritage. The Afro-Ball capped the weeklong celebration as shown in this image.

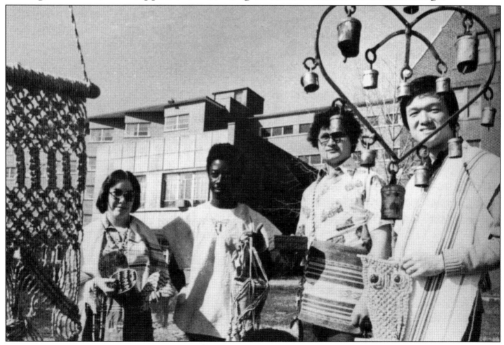

The International Club opened the 1977 school year with a reception for more than 200 foreign students. An International Week was held to allow students from various countries to demonstrate arts and crafts from their homes. This image shows the International Club officers displaying the items for sale during the annual bazaar.

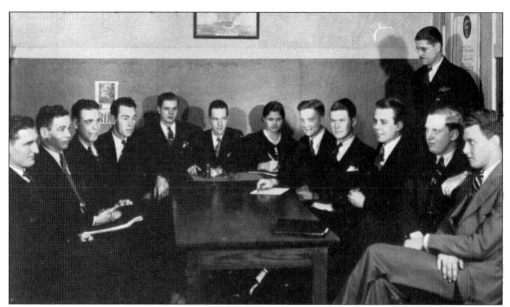

The 1935 student council was composed of 12 students, three of whom were chosen by each class, and was assisted by a faculty sponsor. Chief among the responsibilities of the council were the development of a social program and the sponsorship of Memorial Union activities, which includes regulations for the use of the ballroom, equipment for the recreation rooms, and tournaments for games. The student council was the forerunner to Associated Student Government.

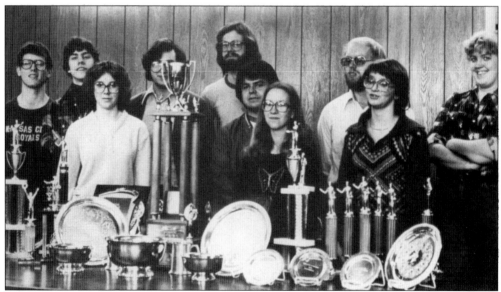

Since the beginning of Kansas State Normal School, members of the literary and oratorical societies have brought home championship trophies to adorn their society rooms and the hallways of the old main building. That tradition of outstanding debaters and debate teams has continued into the 21st century. The debate squad of 1977 is shown here with the numerous awards and trophies from participating in 26 tournaments throughout the year.

One of the most familiar faces on campus belongs to Corky, the Emporia State mascot. Corky came to life in 1933 from the talented hands of 18-year-old freshman Paul Edwards. After entering a mascot contest, his drawing won the student vote. Edwards named him Corky for the personality the Hornet began displaying in a *Corky's Comments* cartoon that Edwards was drawing for the *Bulletin*. Over the years, Corky's head and body have gone through several physical changes. This image of Corky is from 1993.

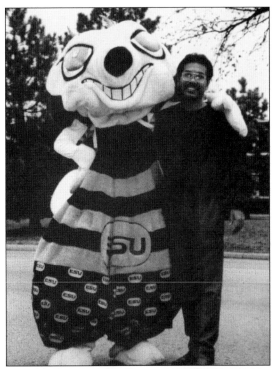

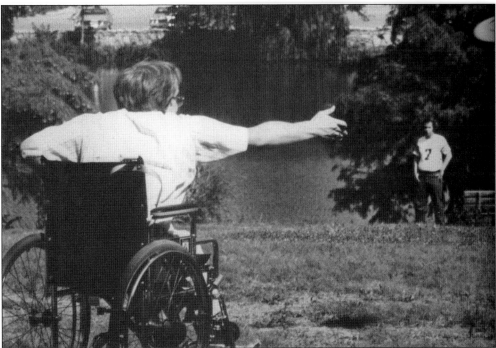

PUSH, People United for Self-Help, was a campus organization dedicated to meeting the needs of disabled students and promoting the interaction and socialization of disabled and nondisabled students. Here, a disabled student does not hesitate to participate in fun activities including an afternoon of Frisbee.

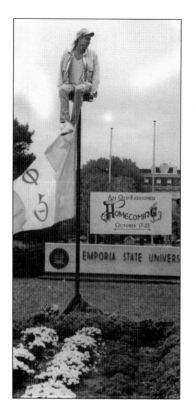

Homecoming weekend is not complete without the annual pole-sit beginning on Friday and continuing through the weekend. Neither rain, snow, sleet, nor hail can keep a member of Phi Delta Theta from sitting on a high pole in front of the university while other fraternity members collect contributions for a needy nonprofit organization.

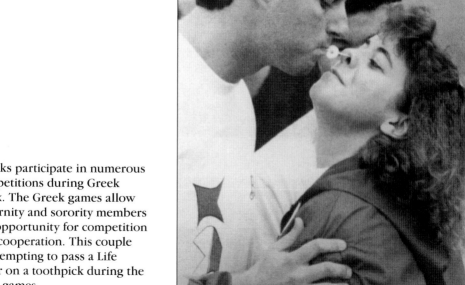

Greeks participate in numerous competitions during Greek week. The Greek games allow fraternity and sorority members the opportunity for competition and cooperation. This couple is attempting to pass a Life Saver on a toothpick during the 1991 games.

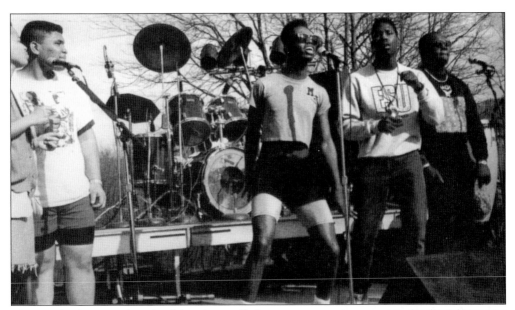

Flintstock, the "Woodstock of the Flint Hills," made its appearance at Emporia State in the early 1980s. Each Flintstock has a theme for that year. In the beginning, three bands performed throughout the day. In 1991, performances by ESU students were added to the concert fun. This image features a rap during the ESU talent session.

Family Day, formerly known as Parents' Day, has been a tradition at Emporia State for many years. Usually held in September on a home football game day, Family Day gives parents and other family members the opportunity to explore the campus and Emporia, attend the game, and become better acquainted with the ESU community. Here, Grandpa Pokey creates a balloon hat for a student before the football game.

The Educational Theater Company (ETC) offers theater majors an opportunity to gain experience. Members of ETC travel around the city of Emporia performing educational skits and acting out children's stories at elementary schools. Here, members of the 2006 ETC act out a "Horton" skit for a Dr. Seuss presentation.

The 1974 Homecoming Musical was one of the most spectacular events during the homecoming weekend. What made it special is the fact that the musical replaced the once popular Curli-Q production held as part of homecoming weekend. The musical *Camelot* featured talented students from across the campus, elaborate costumes, and sets. Proceeds from the musicals go to theater scholarships.

Five

GO HORNETS!

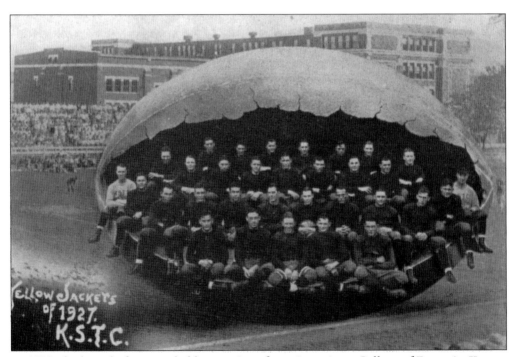

In 1893, the board of regents held a meeting after witnessing a College of Emporia–Kansas State Normal School game and declared that football was banned forever at the normal school. The brutality of the game was the reason for this move on the part of the regents. In spite of dire warnings of regents, legislators, editors, and the public in general, football had not vanished from Kansas State Normal School. On December 15, 1902, an entire issue of the *State Normal Bulletin* was devoted to the praises of the game.

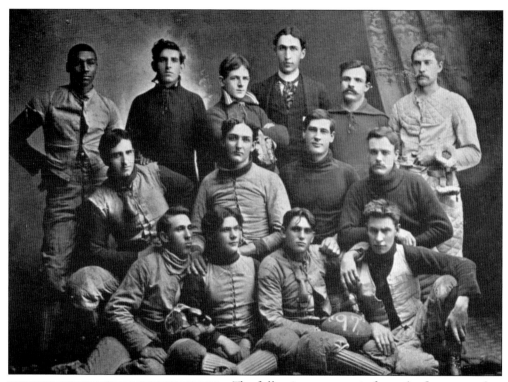

The following comments from the first normal yearbook published in 1898 speak to the game of football at the normal school: "The *Kodak* cannot speak too highly of the foot-ball material in Kansas State Normal. Judging from the inter-society games it seems that the school ought to lead the West in foot-ball. All that is needed is the opportunity to play. If this were granted, much better material would be found in the institution than at present and the necessary expenses of training would easily be met. "

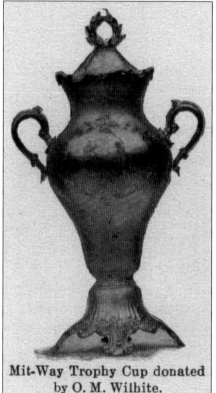

Mit-Way Trophy Cup donated by O. M. Wilhite.

The interim between the football season of 1900 and 1901 revealed the fact that those outside the athletic association of the institution were interested in its welfare. O.M. Wilhite, one of Emporia's best citizens and businessman and a big-hearted supporter of athletics, offered the Mit-Way Cup as a football trophy to be contended for by the Kansas State Normal School and College of Emporia. The trophy was a stimulus to athletics in both schools.

With the Mit-Way Cup as the prize, the Kansas State Normal School and the College of Emporia immediately became in-town rivals. That rivalry continued in football for more than 50 years. So passionate were Emporians over a game that sometimes a school holiday was declared. This 1916 photograph shows the normal-school students and fans marching down Twelfth Avenue to the College of Emporia.

Whether the team was just practicing or playing a game, the playing field north of the Physical Education Building along Merchant Street was always abuzz with onlookers or fans. This 1918 view looking south with the old main building in the background shows the field.

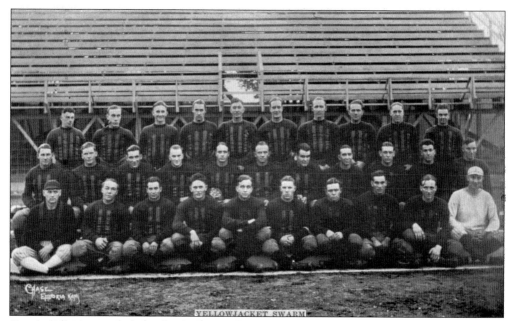

Coach Bill Hargiss led the football squad to many victories on the gridiron. His pigskin squeezers attracted national admiration on account of their consistent hard playing and the good sportsmanship that had been instilled in them by Hargiss. This image shows the 1924 Yellow Jacket Swarm.

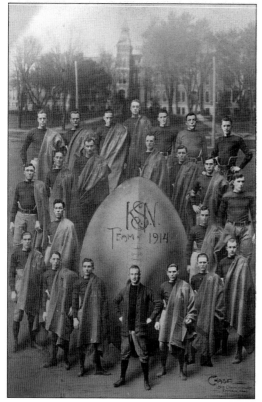

The last game of the 1914 season was at Warrensburg, Missouri. Missouri State Normal School had won its conference championship, as had the normal team from Kansas. This game was to decide the championship of the two states. The weather was ideal for football. At the end of the day, the score was Kansas State Normal, 49, and Missouri State Normal, 0. It was the greatest margin ever between the two schools.

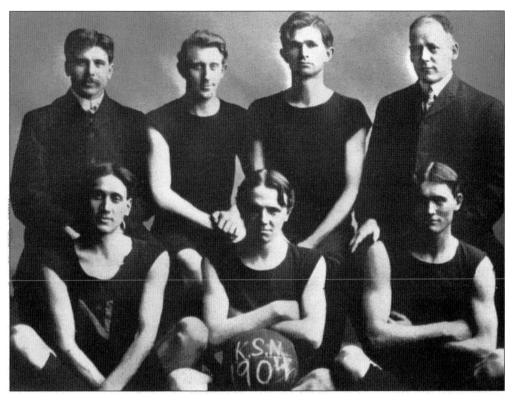

Unlike football, basketball was more readily accepted at the normal school. The game had been popular in the East for some time but was not introduced at Kansas State Normal School until after 1900. The first out-of-town game was played in the Florence, Kansas, Opera House on November 8, 1901.

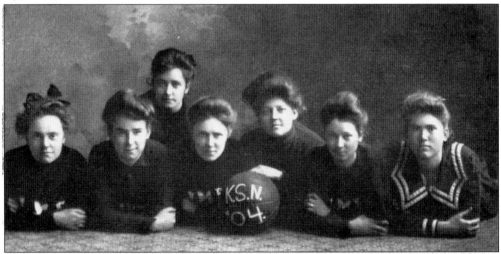

Basketball for women was introduced at the normal school the same time it was for men. According to the board of regents, it was a game that can be well played and thoroughly enjoyed by girls. Therefore, the regents were supportive of the game because the majority of normal-school students were girls. Despite the long-dress uniforms, the girls were able to play a good game of ball.

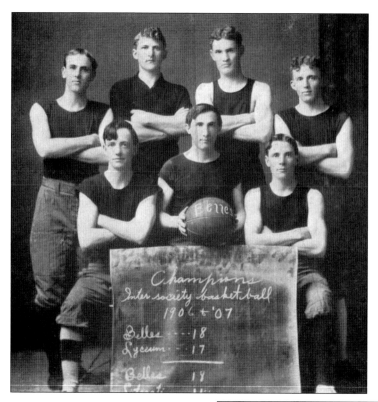

Often, early intramural sports were as passionately fought for as the debate trophies. This image shows the results of the inter-society basketball championship, with the Belles Lettres Society taking the honors.

Under the tutelage of coach E.D. "Gus" Fish, the 1948 Emporia State basketball team won the Central Intercollegiate Conference for a second successive year. Winning the crown allowed the players the right to play in the NAIB Tourney, only to be knocked out in the second round by Louisville, the eventual champion. This season will always be remembered, though, as the one when Emporia State beat Kansas University 67-44.

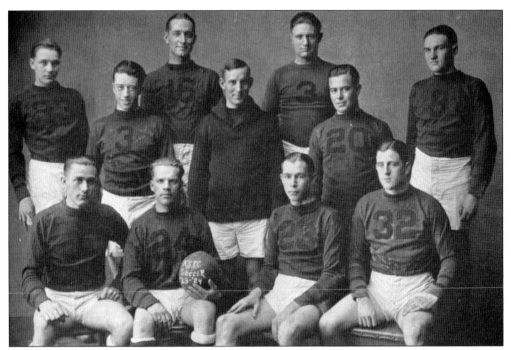

The season of 1911 was a most successful one for soccer at Kansas State Normal School. Four games were played, and only one was lost—to Kansas University on its own turf. In a return game, the normal school won 1-0. There was an increase in interest in soccer as evidenced by the number of Ks being awarded. Ks were awarded to men for their participation in any recognized sport.

In 1929, wrestling was one of the newer sports on the Kansas State Teachers College campus. It was not long before it became one of the most popular of the minor sports activities. The Hornets contested matches with the College of Emporia, Pittsburg, and Hays.

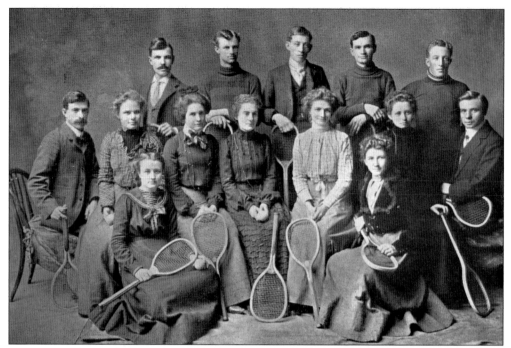

Tennis as a form of athletics at the normal school had come to stay by 1910. Formerly, students had thought of it as a girls' game only, but it was being recognized as a good all-around sport, better suited to all students than any other. While the accommodations for playing tennis at that time were not very satisfactory, improvements were being planned for a large number of courts.

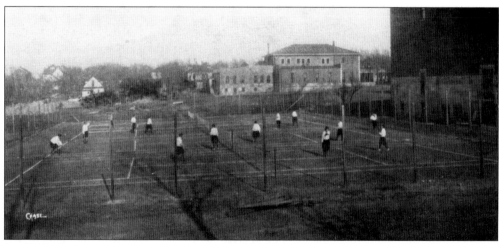

By 1920, the improvements to tennis courts had been made at the normal school, with at least eight courts available for play. The courts were located behind Plumb Hall. The large building behind the courts is the cafeteria on the east edge of the campus where King Hall is located today.

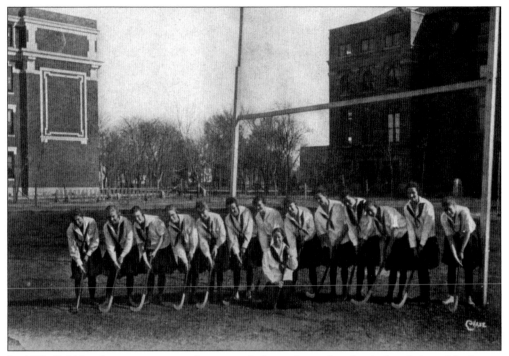

In 1919, field hockey was a game that appealed mostly to the physical training girls. It was thought of as a strenuous game that was difficult to organize into teamwork. Field hockey was played for many years at the normal school. It made a comeback as a women's sport in the 1960s.

This undated image of women bowlers was most likely taken in the 1930s in the Physical Education Building. A legend among bowlers, Floretta Doty McCutcheon most likely made bowling popular during that time. Going on tour, she told women that they could begin bowling at almost any age and in any physical shape.

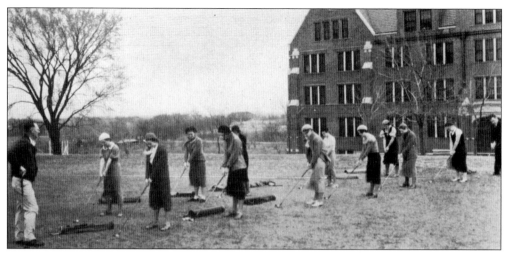

Golf was added the college's curriculum in 1933. A new nine-hole links was completed in the summer on the campus grounds near Morse Hall under the supervision of Prof. C.R. Phipps. The course was offered for the first time during summer school, with Victor Trussler as the instructor.

Archery was a new women's sport that was added to the curriculum of the physical education training department in 1928. Even though the target is two feet in diameter and only 60 paces off, the sport requires upper-body strength and skill in accurate aim. Many of the women took archery as an extracurricular sport.

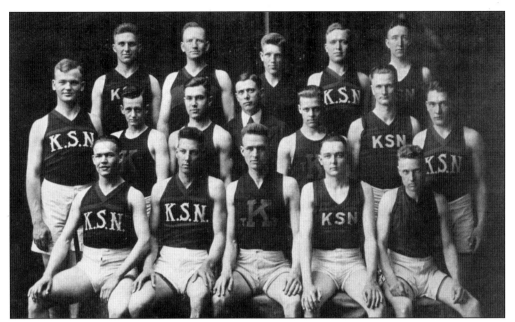

In 1918, Uncle Sam had conscripted most of Kansas State Normal's famous track team into military service, so coach Bill Hargiss had to manufacture a new one for this season. Because track work had been necessarily light that year, with few meets available, the team members did not have the opportunity to test their skills on the field. The 1919 team pictured here is ready for action.

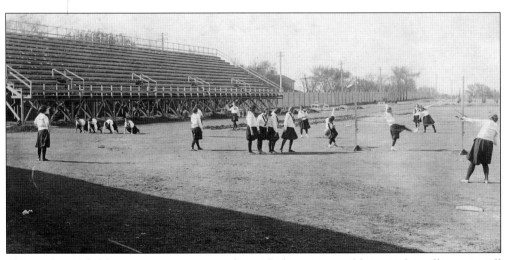

The track-and-field sports were very popular with the women athletes at the college, as well as with the men. Despite the awkward and bulky clothing the women wore as uniforms, they were able to high jump, sprint, and throw the shot put. This image captures the women practicing on the field in the mid-1920s.

Dancing classes proved the most popular of all physical training elective courses. The best dancers out of the intermediate and advanced classes were elected to the Rhythmic Circle, a laboratory dancing class. The Rhythmic Circle members studied types of dancing and worked out their own dances.

With the coming of spring, men's physical education classes and intramural contests took to the outdoors. Track and field, tennis, golf, and baseball were options for students to participate or enroll in for credit. This 1940 image shows a group of men playing softball using the "shirts and skins" uniforms.

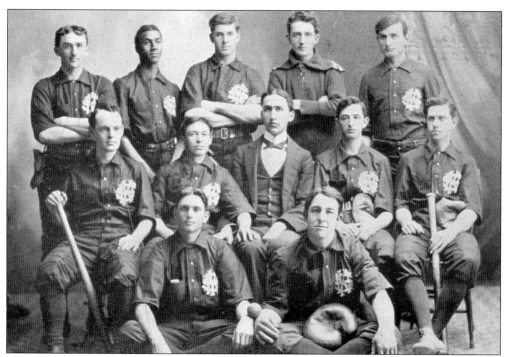

In 1898, the state normal school community members were ardent admirers of the so-called national game, baseball. They always cherished the sport and encouraged the boys to play. However, there was little support from the regents, faculty, or students. Upon the arrival of Prof. Oscar Chrisman, baseball received its great impetus. The season of 1898 opened with unsurpassed enthusiasm as the regents endorsed games being played with other Kansas universities. This image shows the first team in 1898.

At the beginning of the 1949–1950 school year, the Hornets were riding an unprecedented string of six consecutive Central Intercollegiate Conference (CIC) sports titles. Their football teams were undefeated in two years of conference play; they had won the three postwar basketball titles; the Yellow Jacket tracksters had dominated the 1949 CIC track meet for a second straight crown. Here is an image documenting the first airplane trip for a Hornets squad; the football team is at the Kansas City airport ready to board a flight to Des Moines, Iowa, to play against the Drake Bulldogs.

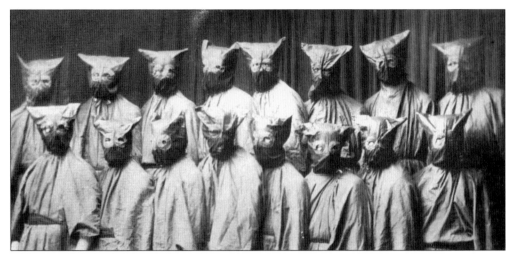

The predecessor to the team name Hornets was the Yellow Jackets. The origin of the Yellow Jackets is not certain. There is an account of a newspaper reporter who was interviewing one of the coaches during a practice session. At that time, some of the normal-school students were wearing sweaters with yellow stripes. No longer wanting to be harassed by the reporter, the coach called them the Yellow Jackets. This image from the 1922 *Sunflower* shows a group of Yellow Jackets who led school pep and spirit.

Large attendance at the basketball games in 1921 made it necessary to have reserved seats in the physical education galleries. So coach Bill Hargiss enlisted the aid of the sororities, each of which appointed two members to act as ushers at all of the home games. The plan proved to be a good one, for those who did not care to watch a basketball game gladly paid the price of admission to see these charming misses. This image shows the 1926 ushers.

Under the guidance of Henry Ellenberger, the 1924–1925 cheerleaders came closest to accomplishing what varsity cheerleaders have been striving for in past generations in cheering. When the "Team work teachers fight" rolled out across the field, the opposing yellers knew they were competing against the best in the state. Young K.C. Jr. participated in spirit but not in voice because he could not talk yet.

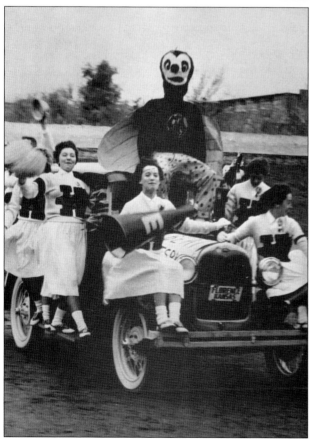

Cheerleading fosters school spirit and encourages the sports teams as they are playing their games. Organized in 1926, Sigma Pi Sigma became the official campus pep club. This group of women led the students and fans in cheering. By the mid-1950s, select women became cheerleaders out of the group, evolving into the current cheerleader squad. This image shows the spirit of the cheerleaders and Corky in the 1956 homecoming parade.

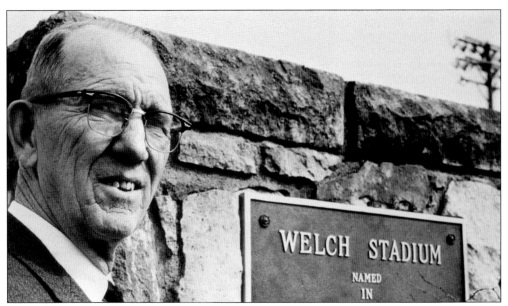

One of the most revered coaches at Emporia was Lyon County native Fran Welch. In 1914, Welch enrolled in the Kansas State Normal School, where he was quarterback of the football team for four years. In 1928, he became the head football coach at KSTC, a position he held for 24 seasons. Also an outstanding track-and-field coach, Welch was selected to coach the American women's track-and-field athletes at the 1960 Summer Olympics in Rome. Welch Stadium is named in his honor. (Courtesy of University Photography.)

Coached by Fran Welch, Emporia State's cross-country team emerged victorious from the Central Intercollegiate Conference meet in 1959 for the third straight year. A week later, the team won the National Association of Intercollegiate Athletics (NAIA) crown by topping a field comprised of entries from 25 schools.

The women's gymnastics team, under the guidance of Marjorie Stone and Suzanne Orazem, physical education instructors, completed its first year in 1967. Events included the balance beam, vault, uneven parallel bars, free exercise, tumbling, and trampoline. Members of the team put on an exhibition for Parents' Day to demonstrate their routines.

The 1984 women's softball team proudly displays its banner and trophy after winning the NAIA National Softball Championship at Kearney, Nebraska. For the second time in four seasons, the team claimed a national title. Players celebrated the victory with iced champagne on the field and then lead a caravan down the main street in Kearney until the horns on the van wore out.

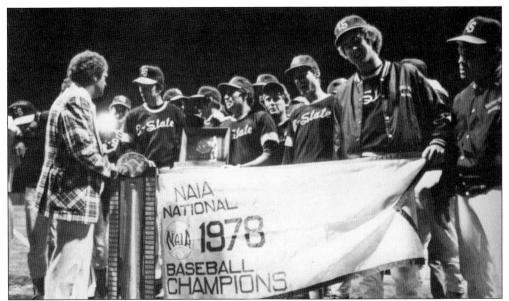

Dave Bingham became head baseball coach at Emporia State in 1975. From 1975 to 1978, the Hornets baseball team took the District No. 10 title every year. The 1976 team won the Area III Tournament and placed third in the NAIA Nationals. In 1978, the team won it all, becoming the top small-college team in the nation and marking the fourth straight consecutive year that Bingham had been named District No. 10 Coach of the Year.

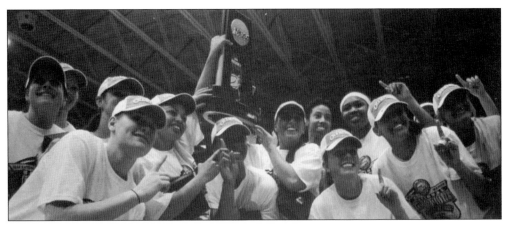

March 26, 2010, was a night that made Emporia State University history. It was the night that the Lady Hornets basketball team won the first-ever NCAA Division II National Championship with a 65-53 victory over Fort Lewis College. For weeks, ESU students and fans had followed the Lady Hornets' victories and were thrilled at the championship, led by Alli Volkens, the Elite-Eight Most Outstanding Player.

In 2006, just his first year as the head coach of the volleyball team, Bing Xu set new standards of excellence in the volleyball program. The Hornets and Xu started the season 13-0 and achieved the goal they set: to make it to the first NCAA Tournament in ESU volleyball history since 1991.

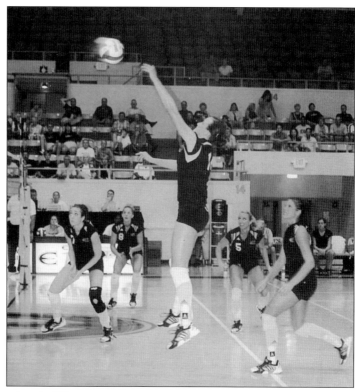

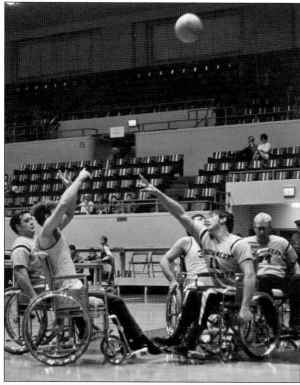

The 1940s saw the beginning of wheelchair basketball. Following World War II, with the return of disabled veterans to college, the sport of wheelchair basketball was added to many athletic programs. With Emporia State becoming one of the best-known handicap-accessible colleges in the 1950s and 1960s, wheelchair basketball games were often held in the civic auditorium, as shown in this image.

Emporia State basketball coach Ron Slaymaker proudly shows the crowd his T-shirt on what it takes to win championships. Coach Slay was an all-conference basketball player at Emporia State from 1957 to 1960. He assumed the head coaching job at Emporia State University in 1970 and served in that position until 1998. Slaymaker won more games than any Hornets coach in school history. From 1988 through 1992, he served as an NAIA representative to the USA Basketball Games Committee.

Emporia State paved the way for women's sports in Kansas, becoming the first NCAA Division II soccer program in the state in 2001. In its first year of existence, the team was able to hold its own in the highly competitive Mid-American Intercollegiate Athletic Association Conference. Preparing for the season, the 2004 soccer team announces its opening game at the pep rally during Hornet Days.

Six

THE WORLD AROUND US

The National Youth Administration was a New Deal agency that focused on providing work and education for Americans between the ages of 16 and 25. Students employed at the teachers college in 1941 numbered 207. There were 91 women and 116 men who worked part-time on campus to help pay their college expenses. Many were employed for campus grounds care, clerical, and general office work.

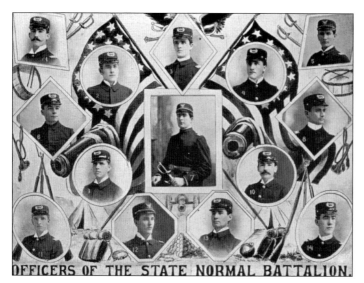

OFFICERS OF THE STATE NORMAL BATTALION.

The Kansas State Normal Battalion was organized in the fall of 1889 by W.C. Stevenson, who consented to a proposition by the boys that they engage in military drill instead of baseball. In the fall of 1891, the battalion reached a membership of more than 100. For some unknown reason, young ladies desired to drill, and Company B was organized in 1892. This image shows the officers of 1898 with Commandant W.C. Stevenson in the middle.

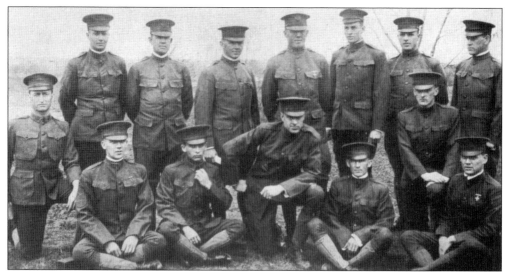

Company L, 2nd Infantry of the Kansas National Guard made its headquarters at Kansas State Normal late in 1915. With the gymnasium for an armory, the campus and athletic field for parade and field work, and the rifle range a short distance out of town, Company L became one of the best-equipped companies in the state. The guards of Company L were almost entirely students from Kansas State Normal School, College of Emporia, and Emporia High School.

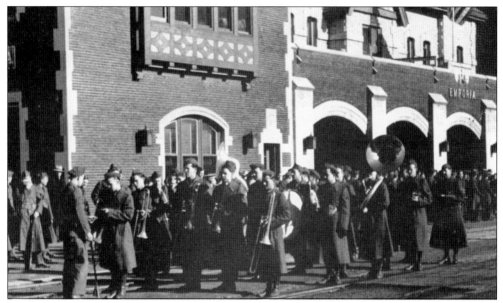

With the onset of World War II, the Emporia State National Guardsmen were called into duty. Many of the guardsmen were sent to Camp Robinson in Arkansas, which was used for basic training and also to house German prisoners of war. The artillery band, comprised of many Emporia State men, furnished music for the send-off to the camp at the Emporia train depot.

A new development on the college campus brought stares from those driving in 1946. Small trailers were lined in rows as housing for the returning World War II veterans and their families. The housing area became known as Vet City. Vet City even had its own government for the residents and by the residents, with a mayor and three councilmen. Although not a glamorous city, it met the needs of returning war heroes.

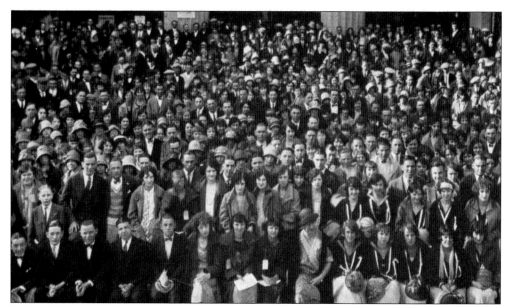

In 1912, under the direction of music professor Frank Beach, 500 invitations were issued to music teachers and students for a recital and reception to show the advantages of the music department at the Kansas State Normal School. The All-Kansas Music Festival became a model for other states, allowing students to compete with each other in the field of music. This 1925 photograph shows the 3,000 contestants representing 202 Kansas public schools gathered in front of Plumb Hall.

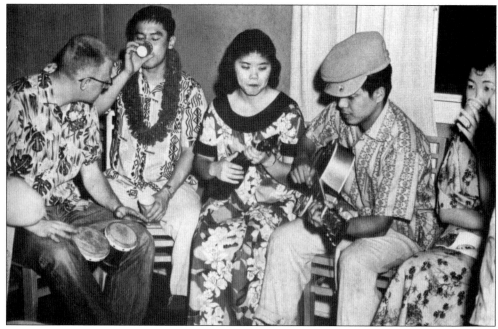

Excitement was at a peak in the nation with the admittance of Hawaii as the 50th state in the Union in August 1959. As there were many students from Hawaii on campus, they shared their excitement by singing and dancing in traditional Hawaiian outfits—the muumuu, kekepa, and aloha shirts—as shown in this image.

Many famous people were brought to Emporia through the university, cultural art organizations, and civic leaders. Students and faculty had the opportunity to hear and enjoy experts in various fields. Eleanor Roosevelt opened the Emporia Artist Series in 1959 with a speech titled "The Change in the United States over the Last Fifty Years." A record audience attended Roosevelt's appearance at the civic auditorium.

One of the most dramatic events in 1979 was the Iran Hostage Crisis. After the shah of Iran fled the country in early November, the US embassy in Tehran was seized by more than 400 militant students shouting, "Death to America." Sixty-two Americans were taken captive. As a result, the US Naturalization and Immigration Services subjected ESU Iranian students to interviews to confirm their student statuses. Emporia reacted to the Iranian threat much like the rest of the nation.

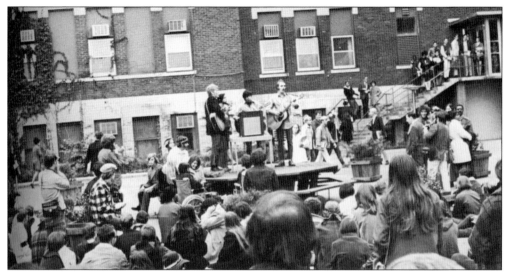

The Peace Moratorium to protest the United States' continuing involvement in the Vietnam War is believed to have been the largest demonstration in the nation's history, with an estimated two million people involved. Thousands of college students across the nation took part in the protest on October 15, 1969. Here, students gather in the student union square to listen to presenters and music regarding the moratorium.

The terrorist bomb attack on the Alfred P. Murrah Federal Building in downtown Oklahoma City on April 19, 1995, was the most destructive act of terrorism on American soil until the September 11, 2001, attacks. The Oklahoma blast claimed 168 lives, including 19 children under the age of 6, and injured more than 680 people. Emporia State students collected donations for the relief fund at the Trusler Sports Complex during Greek games.

The William Allen White Children's Book Award program was founded in 1952 by Ruth Garver Gagliardo, a specialist in children's literature at Emporia State University. It is one of the few literary awards in which young readers choose the winners. This image shows a young reader giving author Elizabeth Yates the first award at a ceremony in 1953 for writing *Amos Fortune, Free Man*.

The National Teachers Hall of Fame was founded in 1989 to recognize and honor the teachers of this country. In June 1992, the first five teachers were inducted into the Hall of Fame at Emporia. This image shows, from left to right, US secretary of education Richard Riley, Hall of Fame teacher Shirley Naples, ESU president Robert Glennen, and Pres. Bill Clinton during a 1993 White House Rose Garden ceremony honoring inductees.

In 1997, a homeless shelter for men was established in a house on Merchant Street near the southwest corner of the campus and was named the Emporia Rescue Mission. In the fall of 1999, the eight resident assistants of Morse Hall and the director of residential life built their own homeless shelter out of cardboard to demonstrate the need to assist those without a place to call home and to raise funds for the Emporia Rescue Mission.

A legacy is the mark one leaves in an organization or the difference one makes in the life of another person. Fraternities and sororities have become the distinguished organizations they are today because of the legacies left by the men and women who founded them many years ago. Part of that legacy is the service given by the Greek organizations. It may be pole-sitting, teeter-tottering, or hanging bras across the bridge of Wooster Lake. Whatever the cause, Emporia State Greek students have fun doing it.

Seven

WITH CHEERS FOR ESU!

Students and the Emporia community love their school and their ESU sports teams, especially the major sports—football, basketball, and baseball. Not only do they support the teams at home, many fans travel to away games yelling and encouraging the athletes to victory with cheers for ESU. Here, the crowd is cheering in White Auditorium, which has almost become as fabled as Kansas University's Allen Fieldhouse in Lawrence.

A TRAINING SCHOOL PRODUCT.

Since its inception, the mission of the Kansas State Normal School was to prepare teachers to teach. This mission was fulfilled through the Training School, where students learned to excel in teaching at the kindergarten, primary, intermediate, and high school levels. The 1904 *Sunflower* yearbook boasts, "This great institution, with all its departments, is devoted wholly to training people to teach school, and we are the school. We are the tail that wags the dog." This image represents a teaching school product.

These young women in 1916 are proudly displaying their devotion to the Kansas State Normal School on the front porch of their living quarters. Thomas Butcher had assumed duties of the presidency only three years before this photograph. Enrollment was increasing, and the new administration building was under construction.

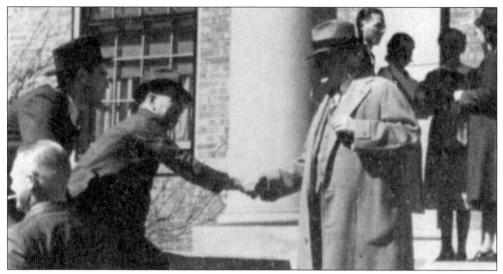

Although Founders' Day had been observed through the years on February 15, it was not until 1907 that the day became a recognized date of celebration. At a Kansas State Normal School chapel on February 8, 1907, President Hill announced that beginning with February 15, 1907, the day would be an "institutional day" and that a "suitable program would be planned in its honor." William Allen White is seen shaking hands on the steps of the Memorial Union on Founders' Day, 1938, the 75th anniversary of the school's founding.

Over the years, Founders' Day has been celebrated in many ways—with dinners, parties, speeches, and special events. One tradition for many years has been cutting the birthday cake at the Founders' Day luncheon. University president John Visser is shown here cutting the cake in 1985.

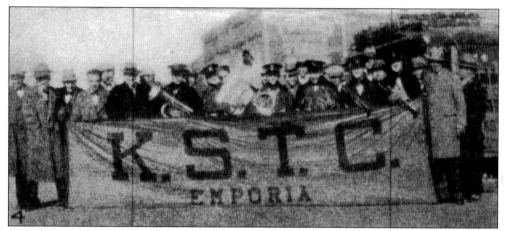

On tour, the Kansas State Teachers College men's glee club took a 1,000-mile road trip across Kansas in the mid-1920s. The tour took them as far west as Haviland, with a stop in Pratt. With large KSTC banners, they traveled by bus and sang with cheer in their voices. This image shows the club, with instruments on top of the bus.

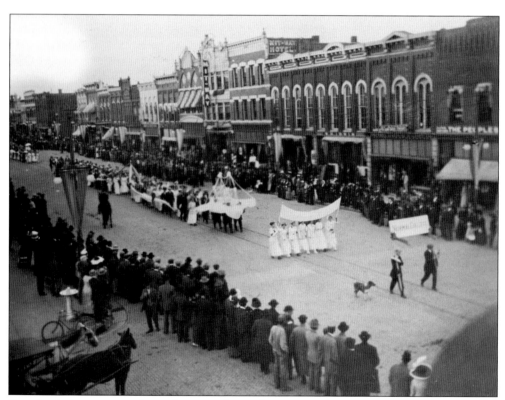

Everybody loves a parade, and no one loves them more than Emporians and the college students. Since the founding of the normal school, Emporians have always been supportive of the institution located in their city. Without the financial support and cooperation during the early years, the school would not have been able to survive. This early-1900s image depicts the school spirit in a parade down Commercial Street.

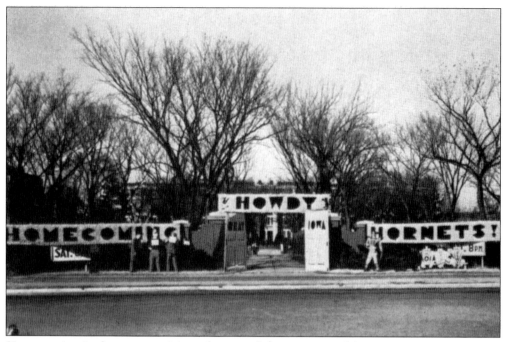

Homecoming is the most anticipated event of the year. A real homecoming welcome was given to the alumni of Emporia State in 1947. Doors opening onto campus were attached to the entrance columns, welcoming back the graduates with a mighty cheer for their alma mater and a "Beat Iowa!"

Many students spend hours planning and putting up decorations during homecoming to welcome home the alums. In 1956, not only did fraternities and sororities decorate their houses, Vet City houses also sported homecoming decorations.

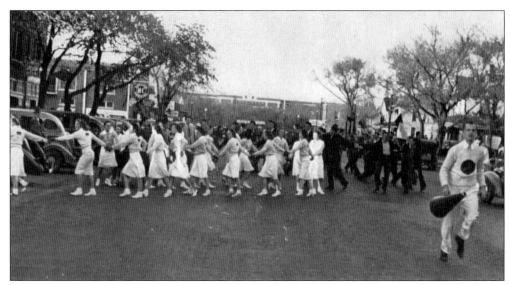

A tradition at many colleges is a snake dance held during homecoming or other special events. A snake dance may be described as a student parade. Students will hold onto each other, creating a snakelike effect. Often, the dance starts in a central business district and ends with an evening bonfire and pep rally near the school. In 1940, Sigma Pi Sigma led the snake dance down Commercial Street before the big game.

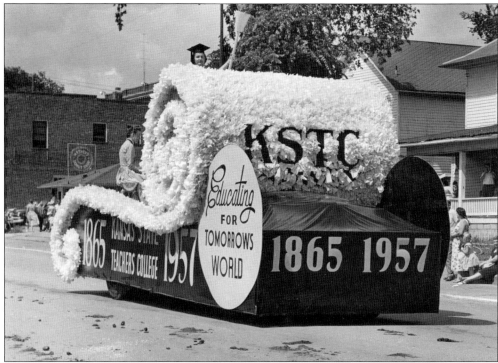

In 1957, the City of Emporia celebrated its 100th anniversary. Events to commemorate its founding took place throughout the year, with one of them being a large parade. This entry from the Kansas State Teachers College reminds the parade-goers that KSTC is "educating for tomorrow's world."

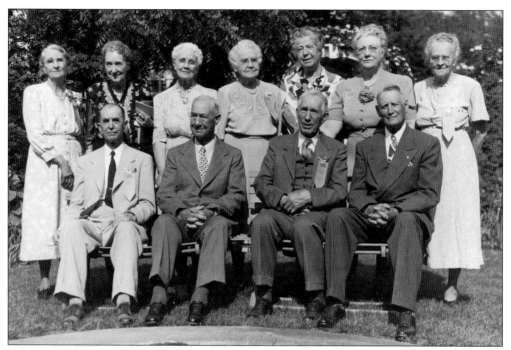

Back for a 50-year reunion, the class of 1898 poses for a group photograph near the Sunken Garden fountain in 1948. The class recalled with cheer the fond memories that had been made during their years at Kansas State Normal School.

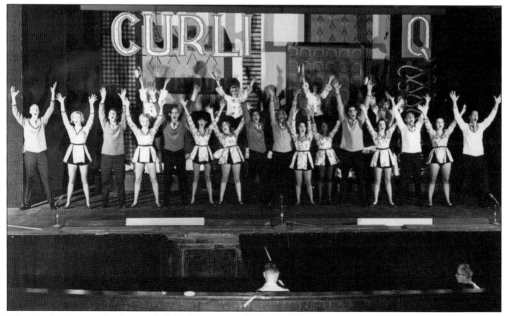

The Curli-Q was the brainchild of music and theater professors Charles Hendricks, George Pflaum, and Karl Bruder and business manager R.G. Cremer. The first production was held in 1947, and productions continued until the early 1970s. The event was an extravagant variety show featuring students and faculty members. Curli-Q was enjoyed by hundreds during homecoming week.

Through the years, Emporia State has changed the lives of many people by making the campus accessible to all students. Due to the special accessibility ramp and viewing stand in the stadium, these students with disabilities along with the other fans are able to cheer on the Hornets at an ESU football game in the late 1950s.

Hornets fans are not mild, meek onlookers. Hornets students and supporters propel themselves with gusto in the cheering sections at major sporting events. Emporia State has averaged over 100,000 fans a year attending home games in recent history. As seen in this

In 1970, activities of the Black Student Union played a major part in the homecoming festivities. With the crowd celebrating and cheering, the candidates made their way onto the football field. Alvertis Holliday and Rosalyn Watson were crowned Mr. and Miss Black Student Union for 1970.

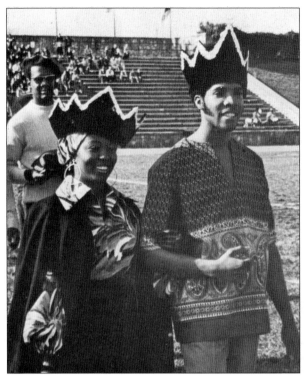

image from a 2004 home football game, the enthusiasm and shouts of "Go Hornets" by the students help stir up the crowd to root for a victory

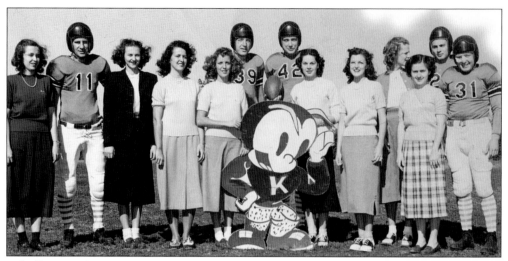

At ball games, homecomings, parades, and school and community events, Corky is sure to be seen. Whether he is made out of cardboard or the real thing, Corky is there to cheer on the Emporia State Hornets. In 1948, he is center stage as he poses for a group photograph with members of the football team and candidates for Miss Peggy Pedagog.

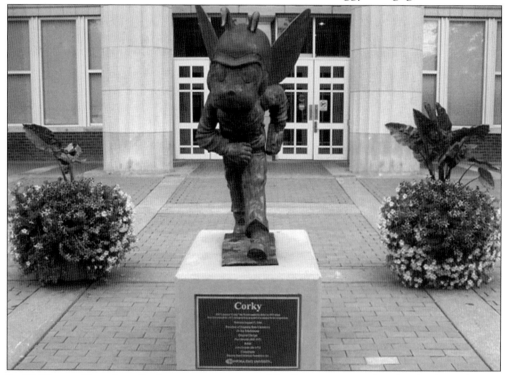

In 2003, ten fiberglass Corkys were sponsored by businesses and individuals and were decorated by artists. The statues were an idea borrowed from other cities and college towns, including Kansas City, Lindsborg, and Lawrence. They were displayed at sponsoring organizations and auctioned to raise money. One of those Corkys was turned into a bronze statute that now guards the entrance to Plumb Hall and welcomes new students and alumni to the ESU campus.

The bridge across Wooster Lake was built in 1928 to carry steam pipes from Morse Hall to the cafeteria. Over the years, the bridge has become a landmark and a romantic spot on the campus. The two most popular legends about the bridge are that the person someone kisses on the bridge at midnight will be the person he or she marries, and that a long and happy marriage is assured if a marriage proposal occurs on the bridge. Rebuilt in 1999–2000, the bridge will continue to span Wooster Lake for future students to carry on the legends.

This symbol, placed in the center of the facade of Plumb Hall in 1917, is limestone and has been aging gracefully for many years. At that time, Kansas State Normal School had been in existence for 54 years. It had survived financial problems, disasters, and war. It had seen tremendous enrollment growth and an expanding campus. Today, Kansas State Normal School stands as a reminder to the founding of a great teacher training institution.

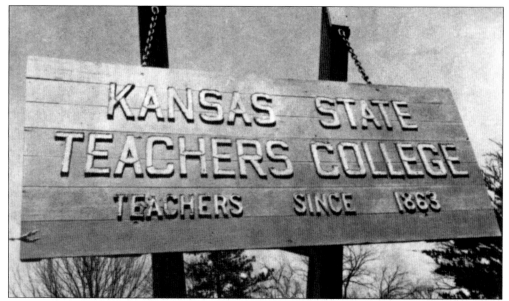

In 1923, the Kansas Legislature passed a bill that changed the name of the three normal schools of the state. The Emporia institution became the Kansas State Teachers College of Emporia. The change was made because the schools had outgrown the general conception of what the public held a normal school to be. Students, alumni, and friends did not accept the official name change immediately. They did not object to the new name but found it difficult because the old name had been associated with the institution for 58 years.

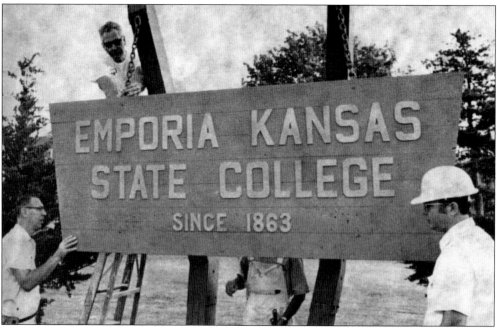

It was 51 years later when another name change was made to the institution. In July 1974, the name was changed to Emporia Kansas State College to reflect the broader liberal arts curriculum being offered. That name change was short lived, however. On April 21, 1977, the board of regents granted university status, and the name became Emporia State University.

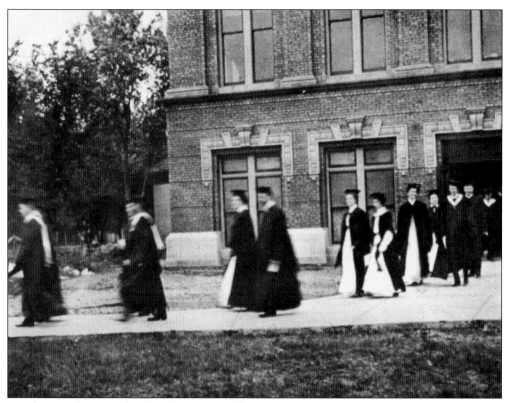

Faculty members are leading this group of Kansas State Normal School seniors out of one of the former campus buildings. Cheering as they go, these young men and women know they have been educated and trained to go out into the world to face the challenges and opportunities that lie before them.

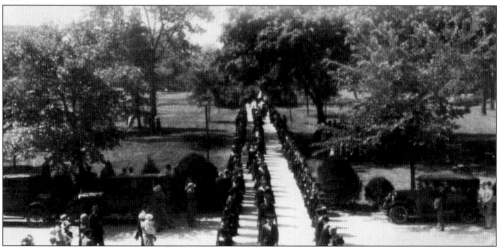

The second Senior Swing-Out in the history of the school took place on April 22, 1931. Members of the senior class visited various buildings on campus. At each stopping place, a member of the class bade farewell to that particular building, and a member of the faculty representing a department in the building made a response. Senior Swing-Out represented the first day that seniors could don caps and gowns.

On Friday, June 28, 1867, the first graduation exercises were held at Kansas State Normal School. The two graduates were Ellen Plumb (left) and Mary Jane Watson whose graduation was witnessed by a large crowd of family and friends.

Since 1867, more than 75,000 students have graduated from this institution built on the prairie lands of Kansas. As they were in 1867, commencement exercises today are times of celebration by students and families. Loud cheers, whistles, and congratulations can be heard as the students receive their diplomas and shake hands with the faculty and friends.